M000160219

Cool Hotels
Paris

teNeues

Imprint

Editor: Martin Nicholas Kunz

Editorial coordination: Nathalie Grolimund

Photos (location): Christoph Kicherer (5 Rue de Moussy), Courtesy Bel Ami, Roland Bauer (Hôtel Bourg Tibourg, Clos Medicis, Le Dokhan's, Hôtel des Grandes Ecoles, Hôtel Jardin de l'Odéon, Kube, Kube backcover bottom, Hôtel Le A, Le Meurice, Le Meurice backcover on top, Murano Resort, Park Hyatt Vendôme, Park Hyatt Vendôme backcover 2nd from top, Pavillon de Paris, Pershing Hall, Hôtel du Petit Moulin, Hôtel du Petit Moulin backcover 3rd from top, Plaza Athénée, Radisson SAS Paris, Hôtel Saint James Paris, Hôtel Sezz), Roland Bauer/Martin Nicholas Kunz (Mayet), Courtesy Montalembert, Roland Bauer/Martin Nicholas Kunz (Montalembert), Jo Frydman (Hôtel Daniel, Hôtel Thérèse, The Five Hôtel), Courtesy Duo Paris, Anne Laure Jacquard (L'Hôtel), Christophe Bielsa/Roland Bauer (Little Palace Hotel), Courtesy Hôtel Saint James Paris, Courtesy L'Hôtel de Sers (L'Hôtel de Sers, backcover 4th from top)
Cover: Roland Bauer (Pershing Hall)

Introduction: Bärbel Holzberg

Layout & Pre-press, Imaging: Jeremy Ellington, Jan Hausberg

Translations: Alphagriese Fachübersetzungen, Dusseldorf

Produced by fusion publishing GmbH, Stuttgart . Los Angeles www.fusion-publishing.com

Price orientation: € < 200 EUR, €€ 201–350 EUR, €€€ 351–550 EUR, €€€€ > 551 EUR

Published by teNeues Publishing Group

teNeues Verlag GmbH + Co. KG
Am Selder 37
47906 Kempen, Germany
Tel.: 0049-(0)2152-916-0
Fax: 0049-(0)2152-916-111
E-mail: books@teneues.de

teNeues Publishing Company
16 West 22nd Street
New York, NY 10010, USA
Tel.: 001-212-627-9090
Fax: 001-212-627-9511

teNeues Publishing UK Ltd.
P. O. Box 402
West Byfleet
KT14 7ZF, Great Britain
Tel.: 0044-1932-403509
Fax: 0044-1932-403514

teNeues France S.A.R.L.
93, rue Bannier
45000 Orléans, France
Tel.: 0033-2-38541071
Fax: 0033-2-38625340

Press department: arehn@teneues.de
Tel.: 0049-(0)2152-916-202

www.teneues.com

ISBN: 978-3-8327-9205-3

© 2007 teNeues Verlag GmbH + Co. KG, Kempen

Printed in Italy

Picture and text rights reserved for all countries.
No part of this publication may be reproduced in any manner whatsoever.

All rights reserved.

While we strive for utmost precision in every detail, we cannot be held responsible for any inaccuracies, neither for any subsequent loss or damage arising.

Bibliographic information published by Die Deutsche Bibliothek.
Die Deutsche Bibliothek lists this publication in the Deutsche Nationalbibliografie; detailed bibliographic data is available in the Internet at http://dnb.ddb.de.

Contents

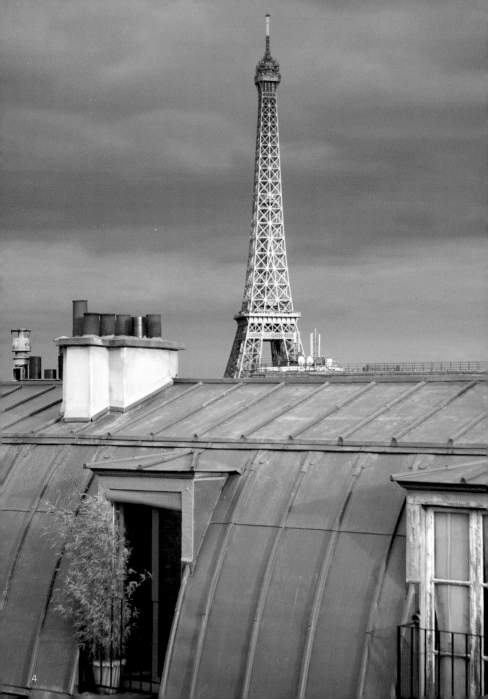

Introduction

Celui qui voyage sur la Seine, veut connaître Paris. Rien ne doit se différencier de l'image usuelle de beauté urbaine et d'élégance généreuse. Seule demeure la question : où habiter ? Sur la Rive Gauche ou la Rive Droite ? Alors, également dans l'un des arrondissements élégant et très bourgeois ou plutôt non-conformiste et intellectuel ? Dans tous les cas, l'hôtel doit être exigeant et raffiné. Ou bien doit-il être plutôt de style futuriste et peut-être même un peu farfelu ? Le guide présent vous proposera son aide pour ces questions essentielles. Car seulement au premier coup d'œil tout semble identique mais sous les façades nobles et de couleur sable uni, cela bouillonne parfois violemment. Le trésor des courants historico-culturels qui opèrent est trop riche, la puissance créative que l'on rencontre à Paris est trop variée et a été incorporée trop volontiers par des Designers comme Jacques Garcia. *L'Hôtel* qu'il a nouvellement aménagé, dans lequel Oscar Wilde a passé les derniers jours de sa vie se révèle être aujourd'hui d'une opulence éclectique un peu décadente. Frédéric Mechiche est parvenu à aménager le grandiose *Le Dokhan's* à la manière d'un palais de ville néo-classique et cependant à inventer le style nouveau du *Le A* moderne. Il a travaillé à la conception de cet hôtel avec l'artiste Fabrice Hybert et a laissé tout l'intérieur tenu en Noir et Blanc à une direction d'artistes. Le Couturier Christian Lacroix utilise de nouveau tout son savoir pour réaliser l'effet de couleurs et de textures et transforme l'*Hôtel du Petit Moulin* en une maison plein d'effets théâtraux. Ce feu d'artifices d'idées créatives a animé la scène des hôtels Parisiens et ne s'incline pas devant les grandes maisons établies. Avec une dépense de plusieurs millions, la Grande Dame *Le Meurice*, rue de Rivoli a été soumise à un lifing de façade cool. Ainsi, le vénérable Paris établit une fois de plus que si parfois, nous devons faire peau neuve si nous voulons rester les mêmes.

Bärbel Holzberg

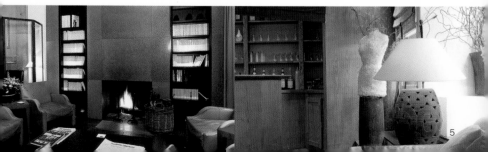

Introduction

Whenever you travel to the Seine, you want to experience the Paris that you know. Nothing should change in the accustomed picture of urban beauty and opulent elegance. The only question that remains is where to stay: Rive Gauche or Rive Droite? In one of the upper middle-class arrondissements or more non-conformist and intellectual? In any case, the hotel should be sophisticated and have exquisite taste. Or should it be styled in a futuristic manner, perhaps even a bit wacky? This guide will assist you in making a decision on these essential questions. Things only look the same at first glance and sometimes there is seething unrest behind the posh sandstone-colored façades. The wealth of art-historical currents that continue to play their role is so rich and the creative potential that meets in Paris is so diverse that designers like Jacques Garcia are happy to absorb it all. The *L'Hôtel*—which he has newly designed and in which Oscar Wilde spent his last days—now appears in an eclectic, somewhat decadent opulence. And the designer Frédéric Méchiche succeeded in furnishing the magnificent *Le Dokhan's* like a neoclassical city palace but completely reinvented himself with the modern *Le A*. He worked together with the artist Fabrice Hybert to design this hotel and turned the entire interior in white and black into an art installation. On the other hand, the fashion designer Christian Lacroix used his concentrated knowledge about the effects of colors and textures, transforming the *Hôtel du Petit Moulin* into a building full of theatrical effects. This fireworks of creative ideas has set the Paris hotel scene in motion. Above all, it also manifested itself at the large, established hotels. At the cost of millions, the grande dame *Le Meurice* on the Rue de Rivoli was subjected to a cool facelift. The venerable Paris uses this example to once again prove that it is necessary to change in order to remain the same.

Bärbel Holzberg

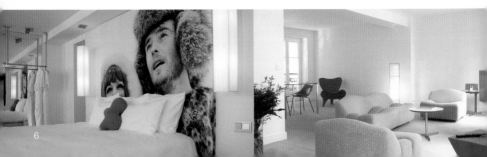

Einleitung

Wer an die Seine reist, will sein vertrautes Paris erleben. Nichts soll sich verändern am gewohnten Bild von städtebaulicher Schönheit und opulenter Eleganz. Bleibt nur die Frage, wo wohnen? Rive Gauche oder Rive Droite? Also in einem der großbürgerlichen vornehmen Arrondissements oder eher nonkonformistisch und intellektuell? Auf jeden Fall anspruchsvoll und von erlesenem Geschmack soll das Hotel sein. Oder doch lieber futuristisch gestylt, vielleicht sogar ein wenig durchgeknallt? Bei diesen wesentlichen Fragen will der vorliegende Führer eine Entscheidungshilfe bieten. Denn nur auf den ersten Blick bleibt alles gleich und hinter den noblen sandsteinfarbenen Fassaden brodelt es mitunter heftig. Zu reich ist der Schatz an kunsthistorischen Strömungen, die weiter wirken, zu vielfältig das kreative Potenzial, das in Paris aufeinander trifft und von Designern wie Jacques Garcia nur zu gerne aufgenommen wird. Das von ihm neu gestaltete *L'Hôtel*, in dem Oscar Wilde seine letzten Tage verbrachte, zeigt sich heute in eklektischer, ein wenig dekadenter Opulenz. Und einem Designer wie Frédéric Méchiche gelang es, das grandiose *Le Dokhan's* wie ein neoklassizistisches Stadtpalais einzurichten, sich mit dem modernen *Le A* jedoch selbst völlig neu zu erfinden. Bei der Gestaltung dieses Hotels arbeitete er mit dem Künstler Fabrice Hybert zusammen und lies das gesamte in Weiß und Schwarz gehaltene Interieur zu einer Kunstinstallation werden. Der Couturier Christian Lacroix wiederum nutzt sein geballtes Wissen um die Wirkung von Farben und Texturen und macht das *Hôtel du Petit Moulin* zu einem Haus voller theatralischer Effekte. Dieses Feuerwerk an kreativen Ideen hat die Pariser Hotelszene in Bewegung gebracht und macht auch vor den großen etablierten Häusern nicht halt. Mit Millionenaufwand wurde etwa die Grande Dame *Le Meurice* an der Rue de Rivoli einem coolen Face-Lifting unterzogen. Womit das ehrwürdige Paris einmal mehr beweist, dass man sich ändern muss, will man gleich bleiben.

Bärbel Holzberg

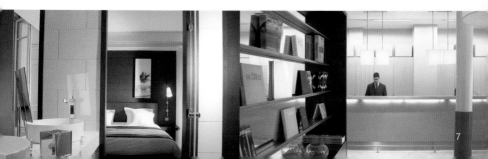

Introducciòn

Quien viaje a lo largo del Sena, experimentará su París de toda la vida. Difícilmente habrá cambios en la imagen habitual de bellezas arquitectónicas y opulenta elegancia. Queda tan sólo una pregunta, ¿Donde alojarse? ¿En la Rive Gauche o en la Rive Droite? Y además, ¿En uno de los respetables arrondissements de la alta burguesía, o en un distrito más anticonformista e intelectual? De todas formas, los criterios de elección deberían ser exigentes y selectivos. ¿Tal vez un hotel en estilo futurista, incluso un poco agujereado? Frente a dudas tan esenciales, la presente guía proporciona una valiosa asistencia en la elección. Aparentemente uniforme y llana, detrás de su noble fachada de color piedra apenaría, a veces hierve enérgicamente. El tesoro de las corrientes histórico-artísticas es demasiado abundante, y sigue proponiendo novedades, y el potencial creativo parisino en continua superposición es demasiado multifacético. Este espíritu es plenamente absorbido y representado por diseñadores como Jacques García, que ha reestructurado L'Hôtel, donde Oscar Wilde transcurrió los últimos días de su vida, y que ahora enseña toda su opulencia ecléctica y un poco decadente. O bien por el diseñador Frédéric Méchiche, que puede llegar a dar al grandioso Le Dokhan's la estructura de un palacio de ciudad neoclásico, o a inventar desde la nada el moderno Le A. Para la creación de este hotel, Méchiche colaboró con el artista Fabrice Hybert, dejando que la decoración, exclusivamente realizada en blanco y negro, se convirtiera en una instalación artística. El diseñador de moda Christian Lacroix ha empleado una vez más su intensa sabiduría en las modelación de colores y texturas, convirtiendo el Hôtel du Petit Moulin en un edificio de efecto absolutamente teatral. Todos estos fuegos artificiales de ideas creativas han puesto en movimiento la escena de los hoteles parisinos, incluyendo en la evolución incluso las grandes casas establecidas. Gracias a un esfuerzo millonario, hasta una primera dama como Le Meurice en la rue de Rivoli ha recibido un nuevo y fresco lifting. Es así como la reverenda París demuestra una vez más como hay que cambiar, si se quiere quedar los mismos.

Bärbel Holzberg

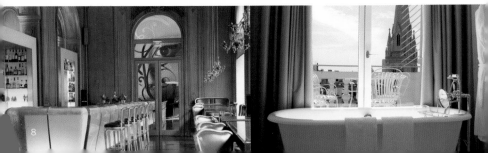

Introduzione

Chi si muova lungo la Senna, ritroverà la sua fidata Parigi di sempre. Non c'è pericolo di sorprese nel quadro abituale di bellezze architettoniche e opulenta eleganza. Rimane solo una domanda: dove alloggiare? Rive Gauche oppure Rive Droite? E inoltre, in uno dei rispettabili arrondissements alto-borghesi, oppure in un distretto più anticonformista e intellettuale? In ogni caso, è bene che la scelta sia esigente e selettiva. Magari un hotel in stile futurista, addirittura bucherellato? Di fronte a tali fondamentali interrogativi, la presente guida offrirà una preziosa assistenza nella decisione da prendere. Uniforme e piatta solo a prima vista, a tratti ribolle energicamente dietro la pregiata facciata color arenaria. Troppo ricco è il tesoro delle correnti storico-artistiche, tuttora in evoluzione, troppo molteplice il potenziale creativo parigino, in continua sovrapposizione, ora pienamente percepito da designer come Jacques Garcia. Sua è la rimodellazione de L'Hôtel, dove Oscar Wilde trascorse i suoi ultimi giorni, che oggi esibisce tutta la propria opulenza, eclettica e lievemente decadente. Un designer come Frédéric Méchiche può arrivare ad allestire il grandioso Le Dokhan's allo stile di un palazzo neoclassico, come a reinventare da cima a fondo il moderno Le A. Méchiche ha collaborato con l'artista Fabrice Hybert alla creazione di questo hotel, e ha lasciato che la decorazione, completamente realizzata in bianco e nero, si trasformasse in un'installazione artistica. Il designer di moda Christian Lacroix ha di nuovo sfruttato la propria intensa conoscenza e gli effetti di trame e colori, e trasformato l'Hôtel du Petit Moulin in un edificio dall'effetto assolutamente teatrale. Fuochi artificiali di idee creative, che hanno messo in movimento lo scenario degli hotel parigini, senza risparmiare nemmeno gli alberghi tradizionali e consolidati. Con uno sforzo milionario, persino una prima donna come Le Meurice in rue de Rivoli si è ritrovata con un fresco lifting al viso. È così che la venerabile Parigi dimostra una volta di più come sia necessario cambiare, se si vuole restare uguali a se stessi.

Bärbel Holzberg

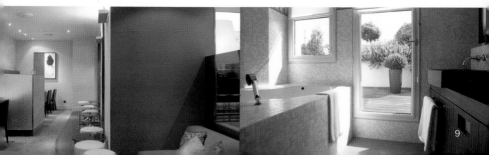

5 Rue de Moussy

5, rue de Moussy
75004 Paris
Le Marais
Phone: +33 1 44 78 92 00
Fax: +33 1 42 76 08 48
www.3rooms-10corsocomo.com

Cool Restaurants nearby:
Café Marly
Kong
Georges

Cool Shops nearby:
Calligrane
A-Poc Space
L'Atelier du Savon

Price category: €€€
Rooms: 3
Located: In the heart of the Marais district
Métro: 1, 11 Hôtel de Ville
Map: No. 1
Style: Contemporary design
What's special: Azzedine Alaïa's urban guesthouse, a sister property of "3 Rooms Corso Como 10" in Milan, offers 3 spacious apartment studios with concrete floors. The studios are populated with the designer's private furniture collection from the 20th century.

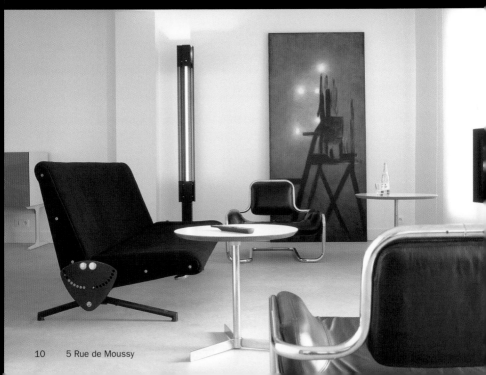

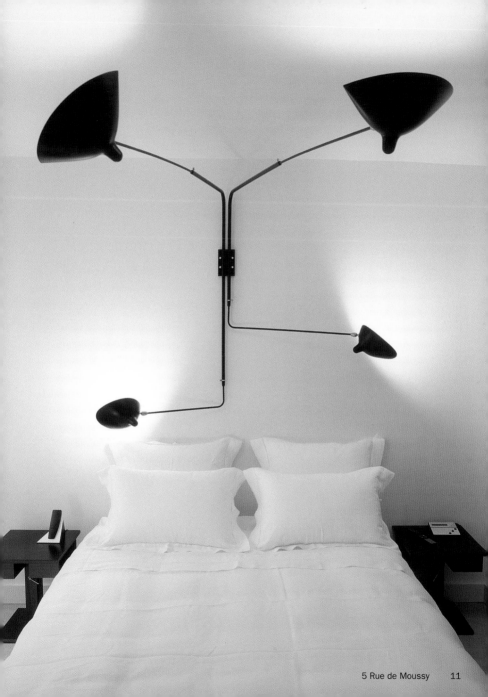

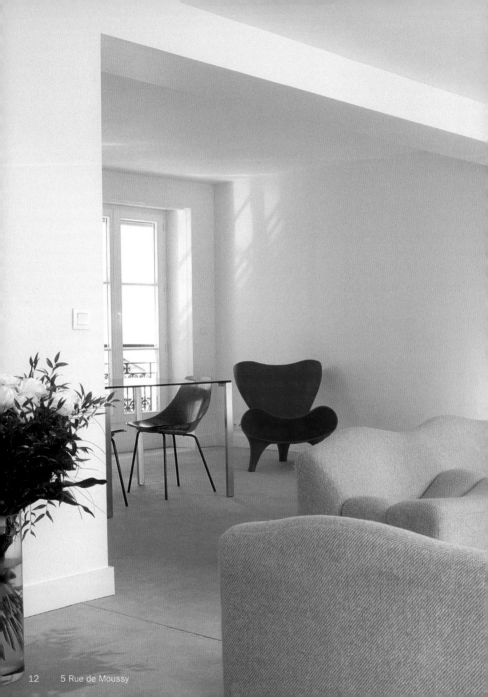

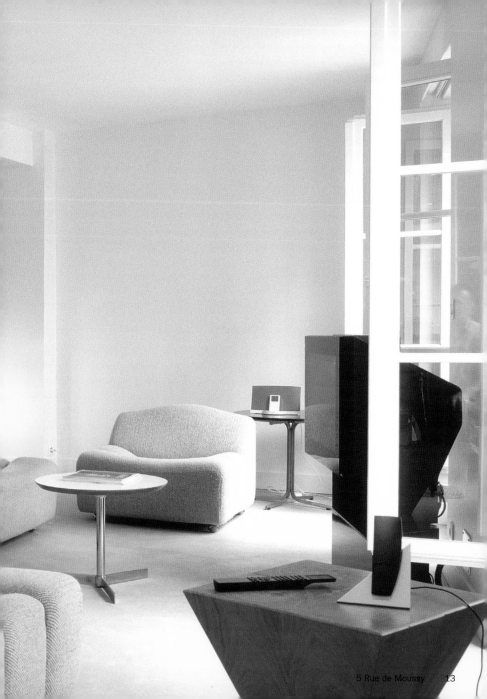

Bel Ami

7–11, rue Saint-Benoît
75006 Paris
Saint-Germain-des-Prés
Phone: +33 1 42 61 53 53
Fax: +33 1 49 27 09 33
www.hotel-bel-ami.com

Cool Restaurants nearby:
Café de Flore
Brasserie Lipp
Arpège

Cool Shops nearby:
Fresh
Orizzonti

Price category: €€€
Rooms: 115 rooms and suites
Facilities: Bar, boutique, lobby lounge
Services: 24-hour concierge service, WiFi lobby Internet stations
Located: Right on Place Saint-Germain-des-Prés
Métro: 4 Saint-Germain-des-Prés
Map: No. 2
Style: Contemporary design
What's special: This sleek designer boutique hotel was designed to appeal to a younger, fashion-conscious audience. The hotel makes extensive use of the finest natural materials and simple lines to create an atmosphere of pared down luxury.

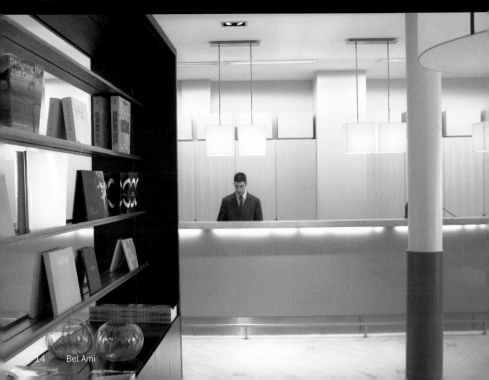

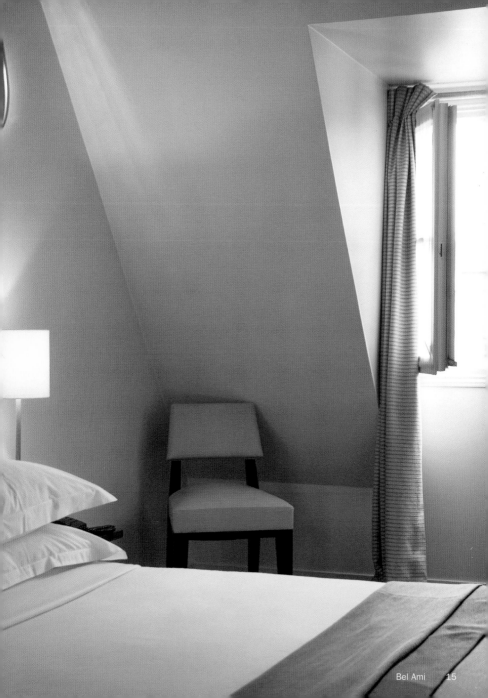

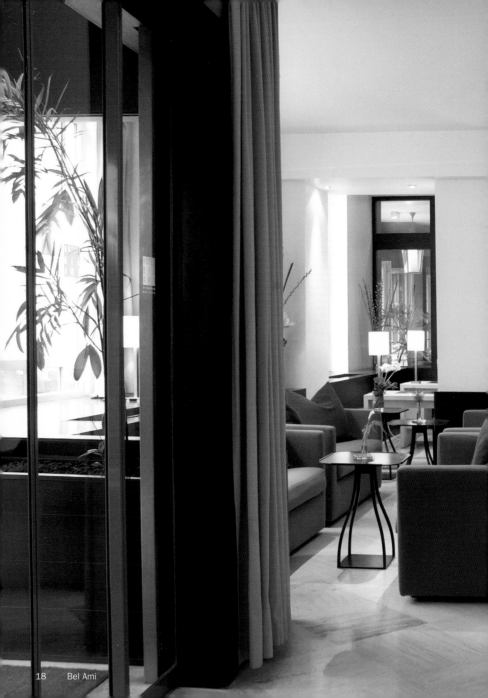

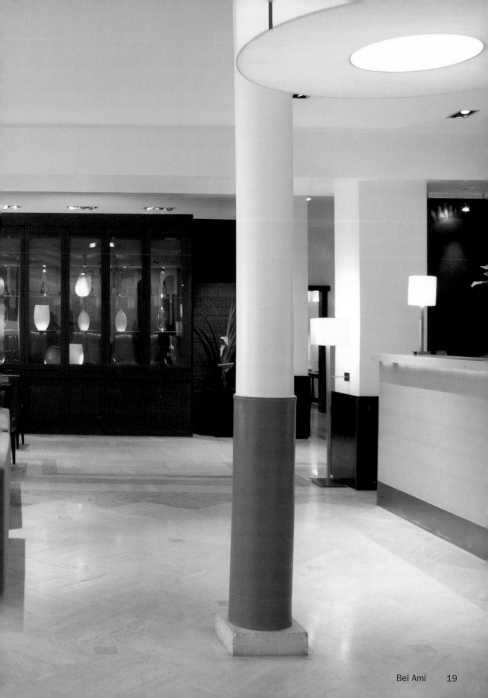

Bourg Tibourg

19, rue du Bourg-Tibourg
75004 Paris
Le Marais
Phone: +33 1 42 78 47 39
Fax: +33 1 40 29 07 00
www.hotelbourgtibourg.com

Cool Restaurants nearby:
Georges
Kong
Murano

Cool Shops nearby:
A-Poc Space
L'Atelier du Savon
Galerie Dansk

Price category: €€
Rooms: 30 rooms
Facilities: Bar, garden
Services: Internet access, safe box
Located: In the heart of the Marais district, walking distance to historic cultural Paris
Métro: 1, 11 Hôtel de Ville
Map: No. 3
Style: Cosy and romantic
What's special: Refurbished by Jacques Garcia in a style more usually associated with the Addams Family, this neo-gothic hotel with Oriental French style opens its front iron doors to uniformly dark rooms that feel like secret dens.

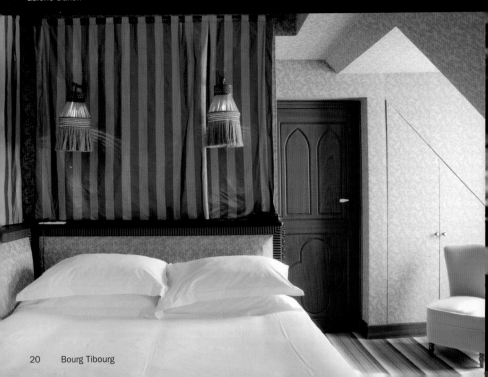

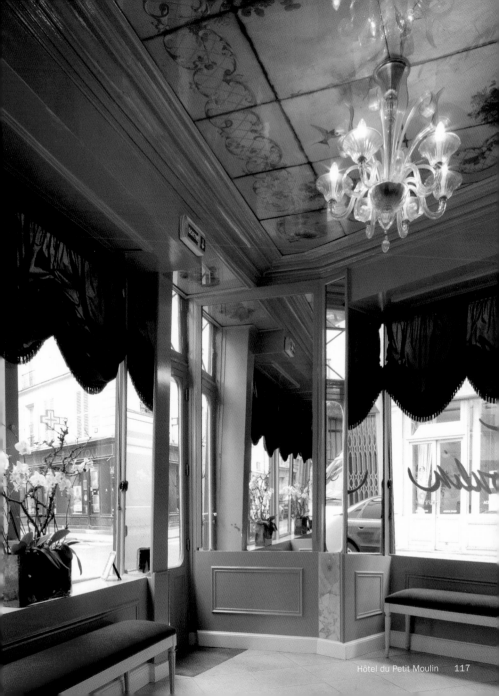

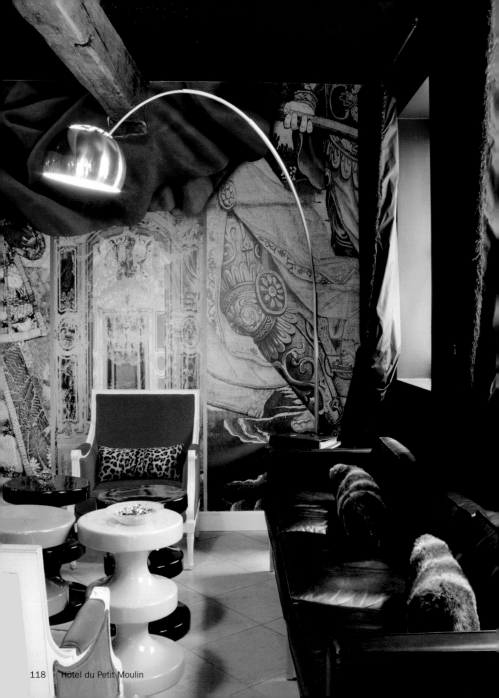

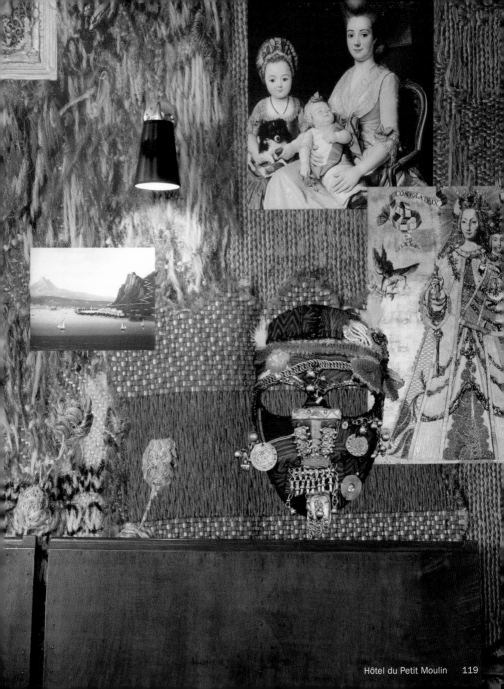

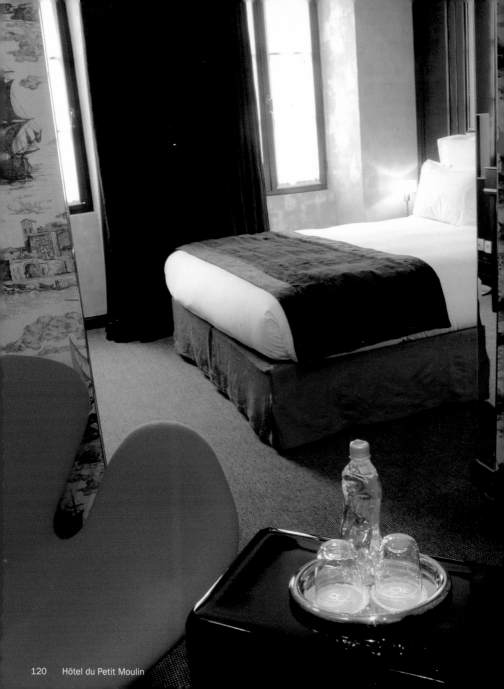

Kube

1–5, passage Ruelle
75018 Paris
Montmartre
Phone: +33 1 42 05 20 00
Fax: +33 1 42 05 21 01
www.kubehotel.com

Cool Restaurants nearby:
Fontaine Gaillon
Etienne-Marcel
Murano

Cool Shops nearby:
Antoine et Lili
Galerie Dansk
L'Atelier du Savon

Price category: €€€
Rooms: 41 rooms and suites
Facilities: Restaurant, Ice Kube Bar by Grey Goose, Lounge Bar, fitness center, meeting rooms, free Internet access
Services: Babysitting, child services, garage parking
Located: A few steps away from the Sacré-Cœur, in a quiet street, sheltered from the city crowds
Métro: 2, RER B, D, E La Chapelle
Map: No. 11
Style: Urban chic
What's special: Behind its classy facade resides a high-tech and innovative world including the "Ice Kube by Grey Goose", the first ice bar in the city. The themes of coolness and transparency are emphasized throughout the public spaces and offset by the warming sense of privacy and comfort that pervades the guestrooms.

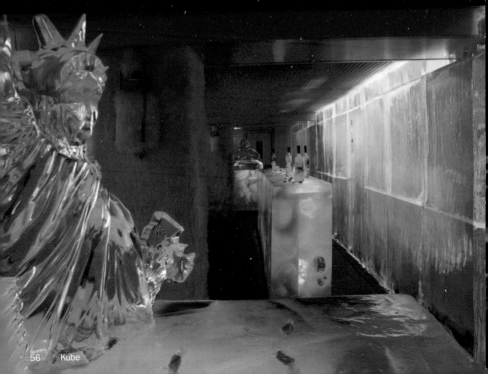

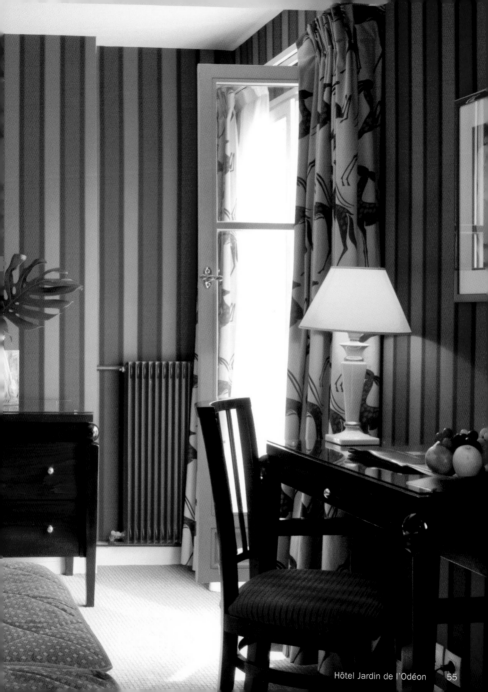

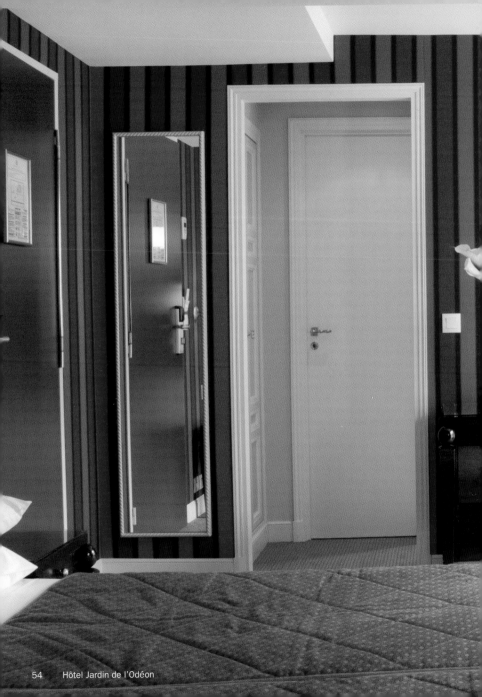

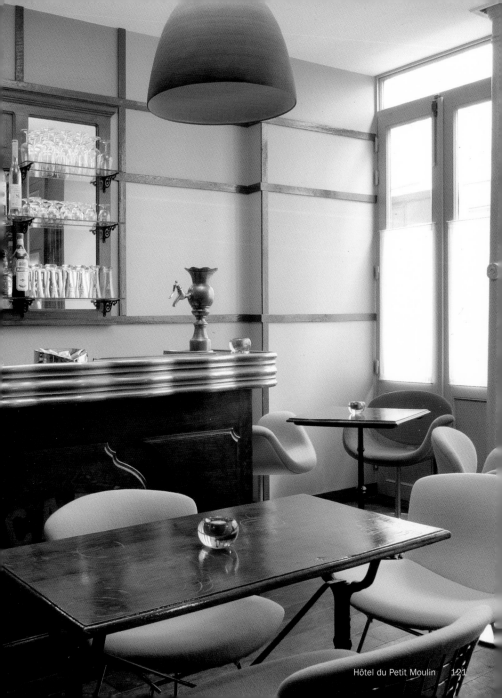

Plaza Athénée

25, avenue Montaigne
75008 Paris
Champs-Elysées
Phone: +33 1 53 67 66 67
Fax: +33 1 53 67 66 66
www.plaza-athenee-paris.com

Cool Restaurants nearby:
Alain Ducasse au Plaza Athénée
Maison Blanche

Cool Shops nearby:
Gucci
Louis Vuitton
Dolce & Gabbana

Price category: €€€€
Rooms: 145 rooms, 43 suites
Facilities: 5 restaurants, bar, meeting rooms
Services: Limousine service, babysitters available, digital television entertainment system (more than 120 channels & 200 movies), Internet access
Located: Between Champs-Elysées and the Eiffel Tower
Métro: 9 Alma Marceau; 1, 9 Franklin D. Roosevelt
Map: No. 23
Style: Classical and Art Deco
What's special: The hotel epitomizes glamour and tradition. A truly Parisian luxury property filled with elegance and charm completely redecorated, it has preserved the spirit and style that made it famous.

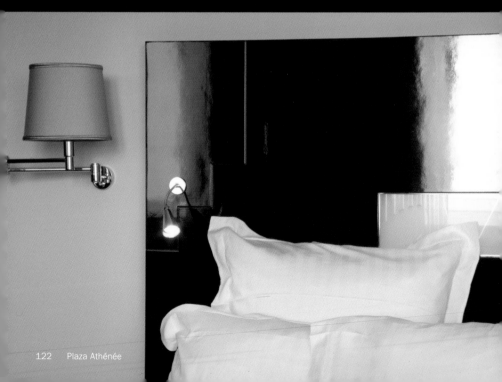

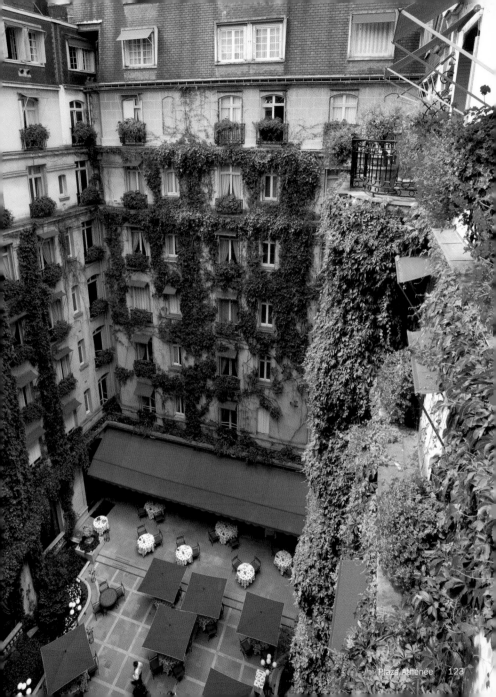

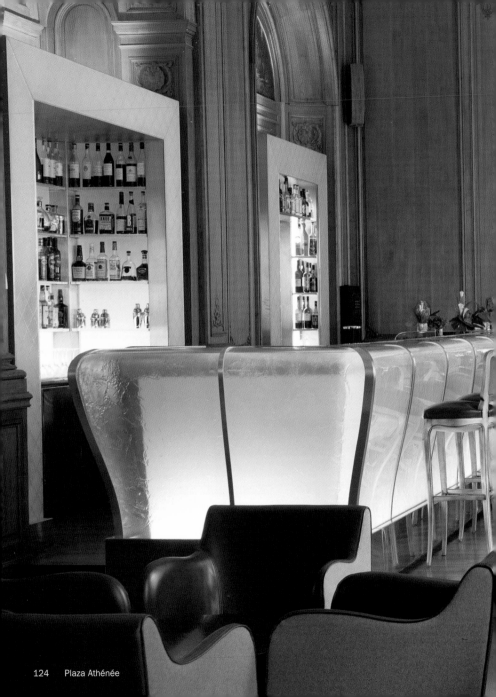

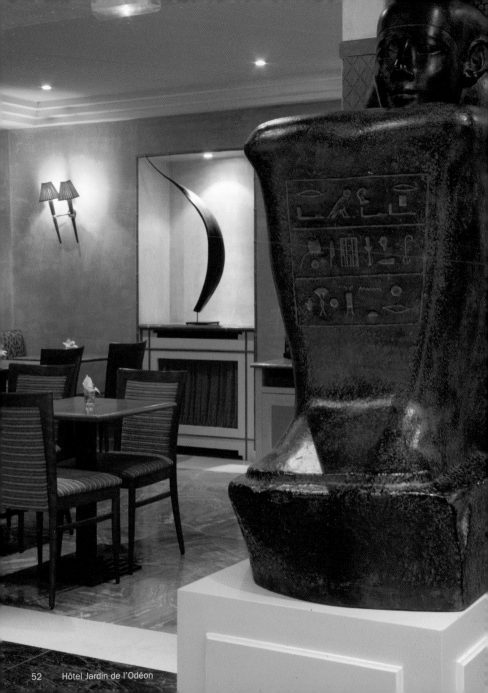

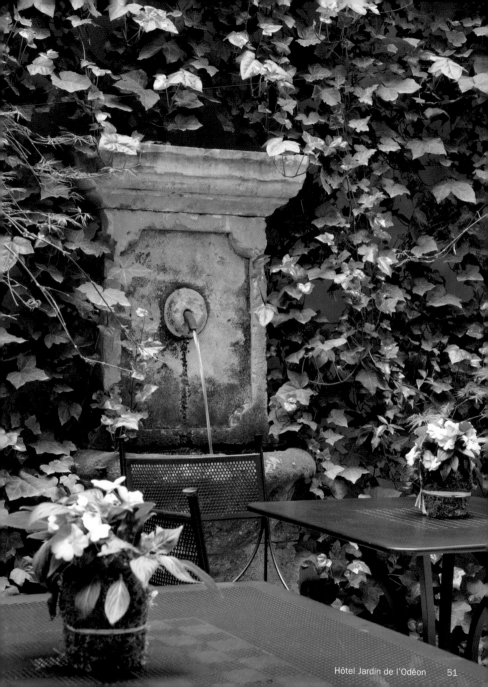

Hôtel Jardin de l'Odéon

7, rue Casimir-Delavigne
75006 Paris
Saint-Germain-des-Prés
Phone: +33 1 53 10 28 50
Fax: +33 1 43 25 28 12
www.hoteljardinodeonparis.com

Cool Restaurants nearby:
Café de Flore
Brasserie Lipp

Cool Shops nearby:
Au nom de la rose
Orizzonti
Fresh

Price category: €€
Rooms: 41 rooms
Facilities: 7 terraces
Services: Fax plugs in each room, free Internet access, entirely non smoking hotel
Located: Close to Saint-Germain-des-Prés, Panthéon and Sorbonne University
Métro: 4, 10 Odéon
Map: No. 10
Style: Classic elegance
What's special: This charming six-storey property next to the Jardin du Luxembourg features decor in rich, bold colors with pictures by Art Nouveau artists such as Gustav Klimt.

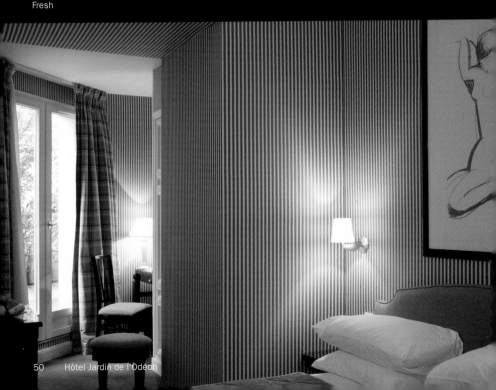

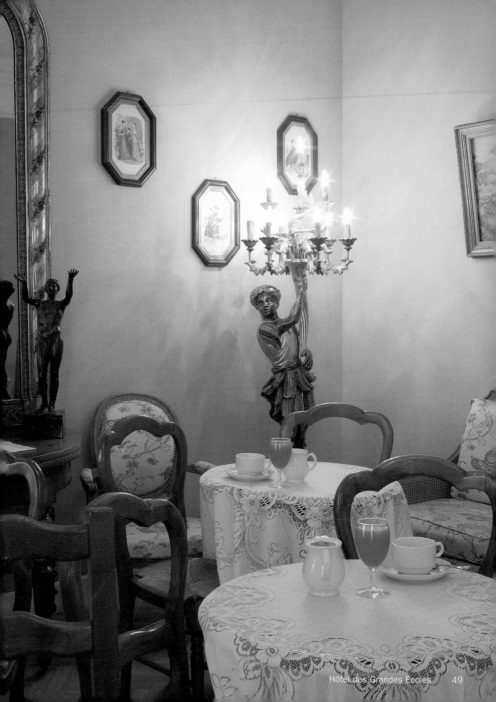

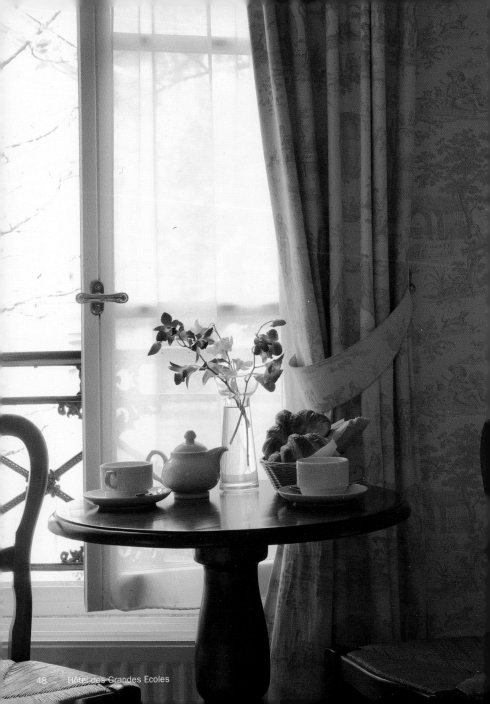

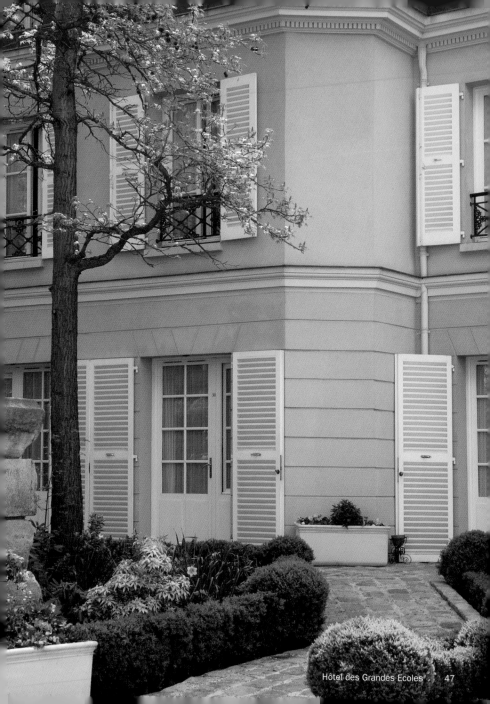

Hôtel des Grandes Ecoles

75, rue du Cardinal-Lemoine
75005 Paris
Quartier Latin
Phone: +33 1 43 26 79 23
Fax: +33 1 43 25 28 15
www.hotel-grandes-ecoles.com

Price category: €€
Rooms: 51 rooms
Services: Pets admitted, babysitting
Located: Near the Panthéon, Sorbonne and Jardin des Plantes
Métro: 10 Cardinal Lemoine
Map: No. 9
Style: Cosy and romantic
What's special: Located in the heart of Hemingway's Latin Quarter this country-style, low-key charm, family atmosphere hotel has 51 old-fashioned rooms set around a garden where breakfast is served in the warmer months.

Cool Restaurants nearby:
Brasserie Lipp
Café de Flore

Cool Shops nearby:
Calligrane
Galerie Kreo

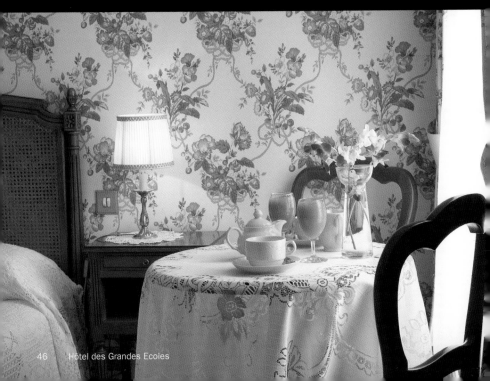

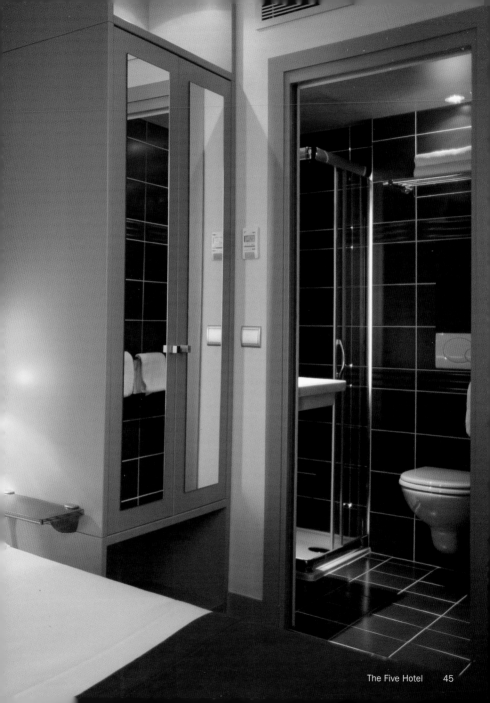

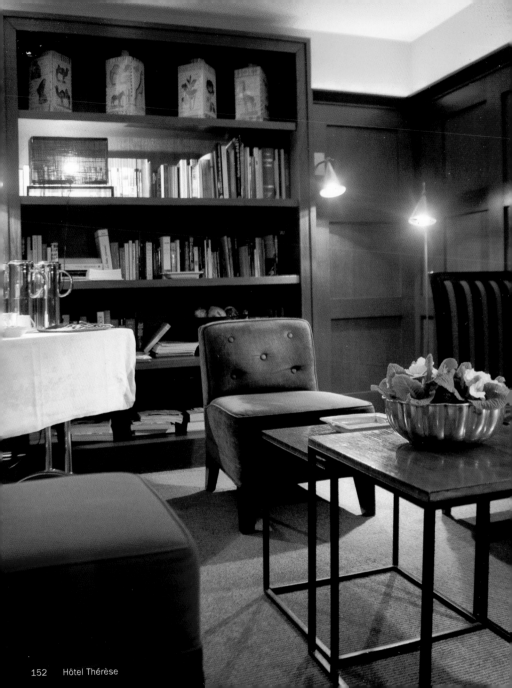

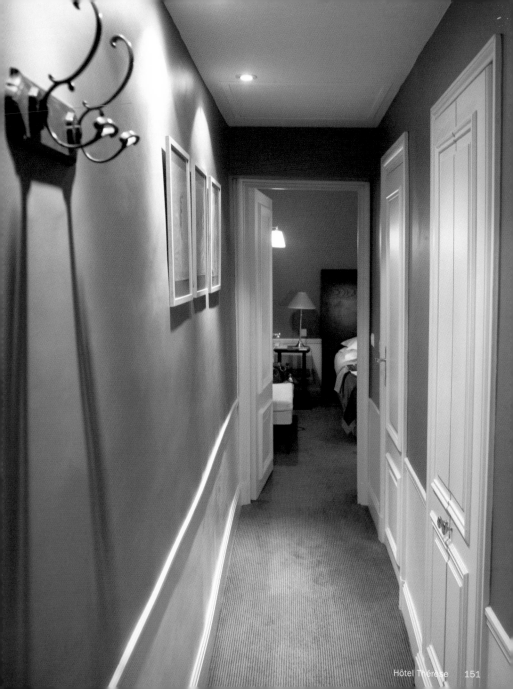

Hôtel Thérèse

5/7, rue Thérèse
75001 Paris
1er Arrondissement
Phone: +33 1 42 96 10 01
Fax: +33 1 42 96 15 22
www.hoteltherese.com

Cool Restaurants nearby:
Café Marly
Etienne-Marcel
Water Bar Colette

Cool Shops nearby:
Les Salons du Palais Royal Shiseido
Biche de Bere
Boutique John Galliano

Price category: €€
Rooms: 43
Facilities: Seminar room, lounge
Services: Conference room, continental buffet breakfast
Located: In the heart of Paris's elegant Rive Gauche, close to the Louvre, the Palais Royal, place Vendôme and the Opéra
Métro: 7, 14 Pyramides; 3, 7, 8, RER A Opéra
Map: No. 28
Style: Contemporary design
What's special: A revitalized 18th century townhouse now hosts a sophisticated design hotel with 43 rooms. Striking vaulted breakfast room, lobby and paneled library give this hotel an elegant and relaxed atmosphere.

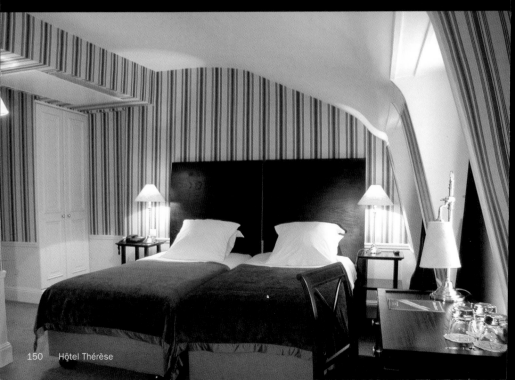

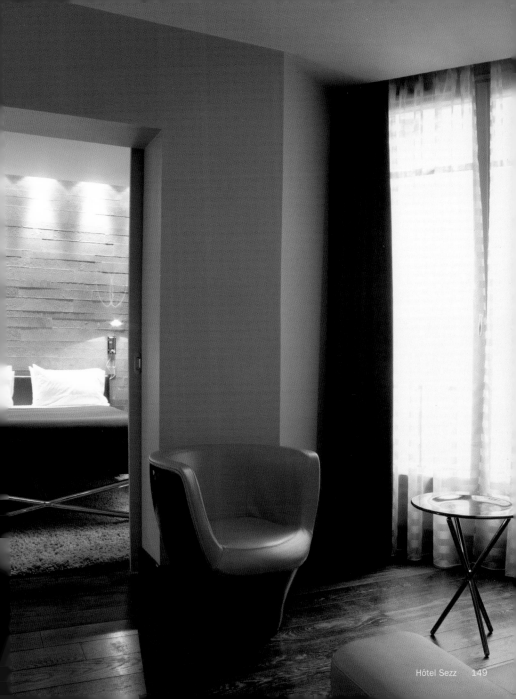

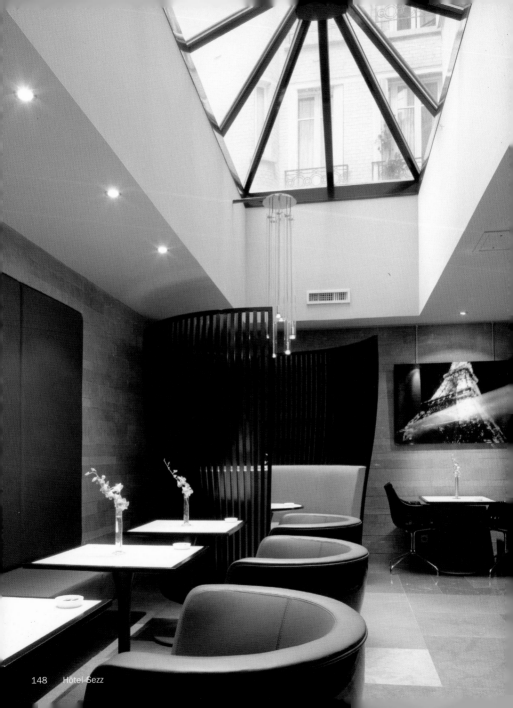

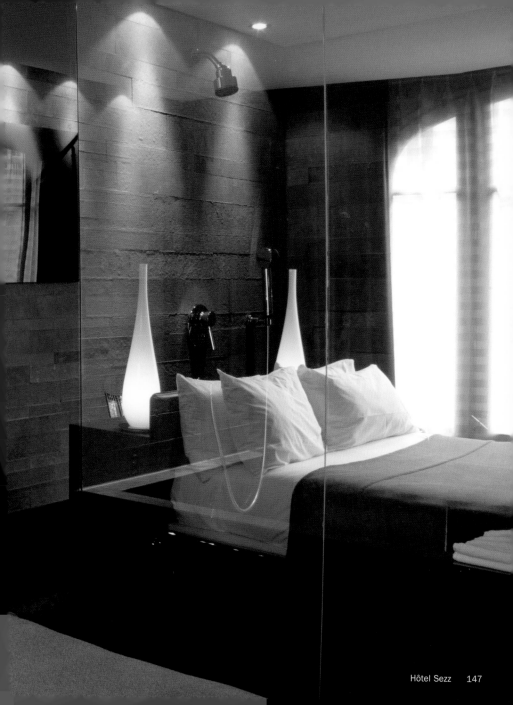

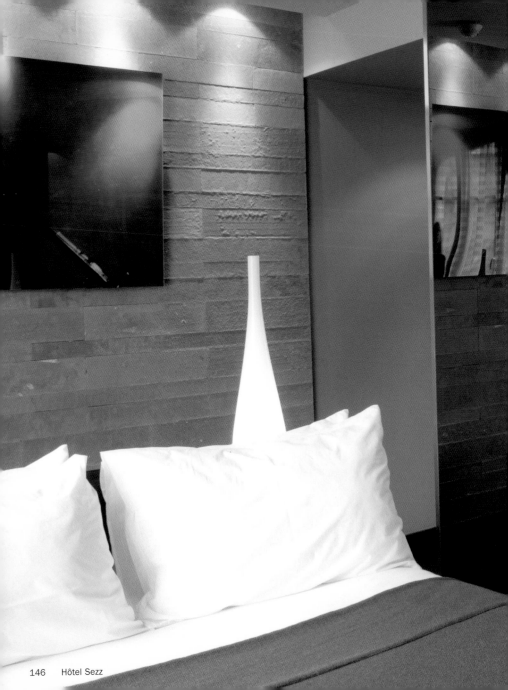

Hôtel Sezz

6, avenue Frémiet
75016 Paris
16e Arrondissement
Phone: +33 1 56 75 26 26
Fax: +33 1 56 75 26 16
www.hotelsezz.com

Cool Restaurants nearby:
Café de l'Homme
The Cristal Room Baccarat
Tokyo Eat Palais de Tokyo

Cool Shops nearby:
Gucci
Louis Vuitton

Price category: €€
Rooms: 13 rooms, 14 suites
Facilities: Bar La Grande Dame, meeting room, jacuzzi, steam, massage room
Services: Flat screen TV, DVD/CD player, free movies, wireless phone with direct line and voice mail, personalised visits to the Veuve Clicquot cellars, boat hire on the Seine
Located: 1 block to Seine and 2 km from Champs-Elysées
Métro: 6 Passy; RER C Champ de Mars/Tour Eiffel
Map: No. 27
Style: Contemporary design
What's special: Meet the future of luxury design. Decorated in muted shades of deep red, mustard yellow and brown, designed furniture and grey stone walls exudes a cosmopolitan and Zen-like atmosphere.

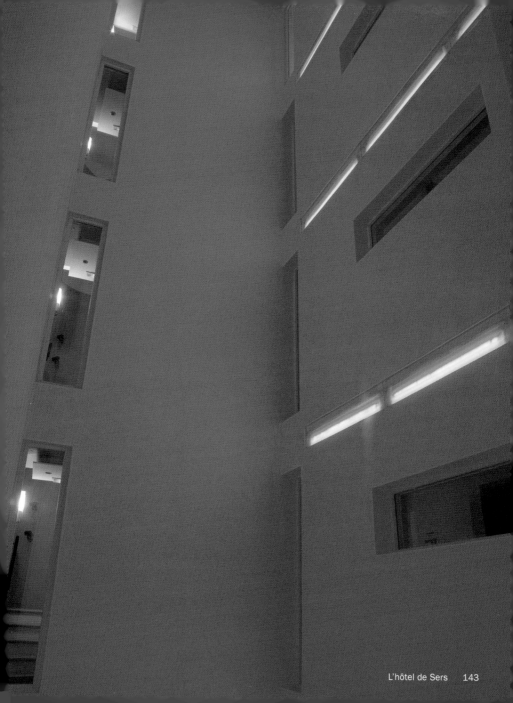

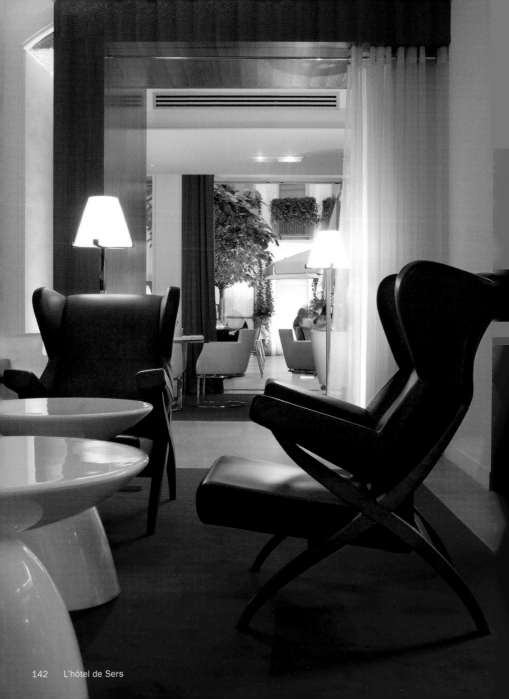

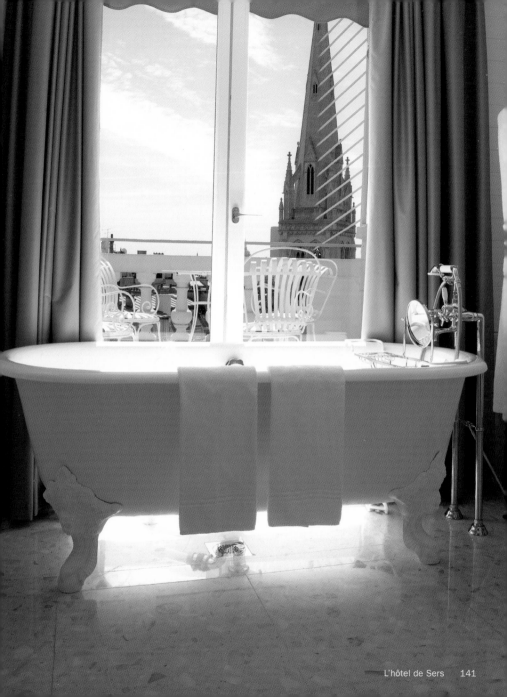

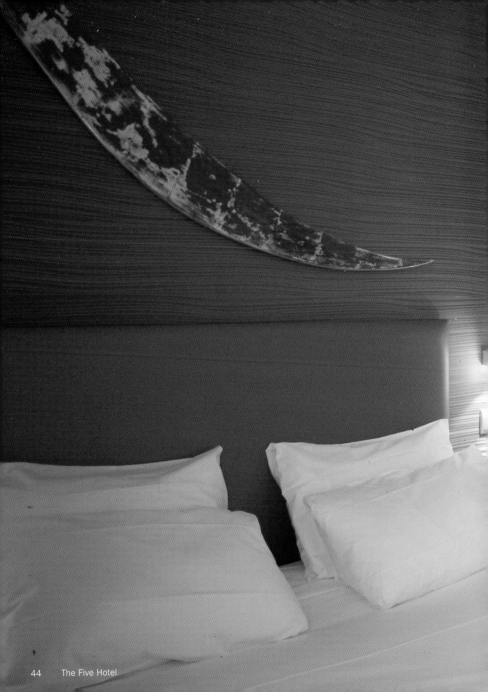

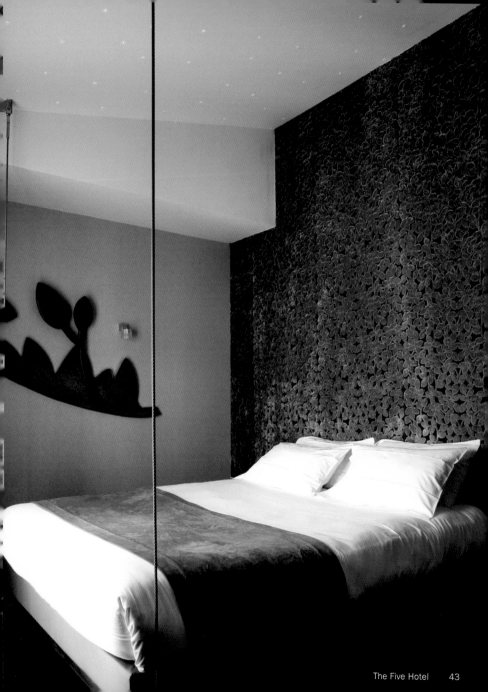

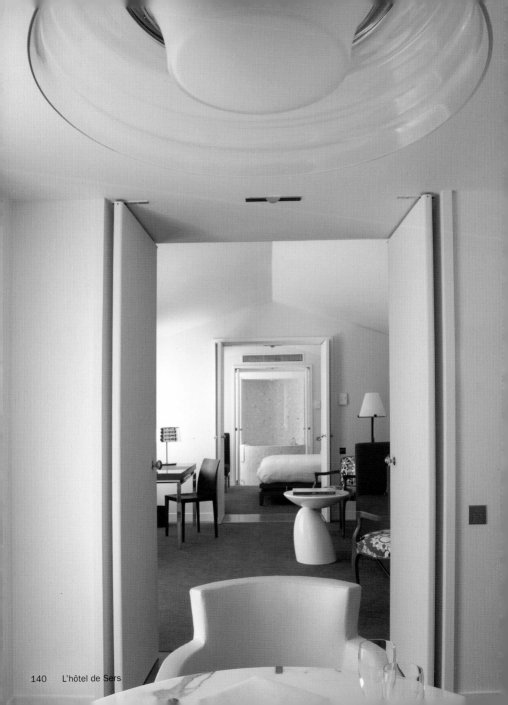

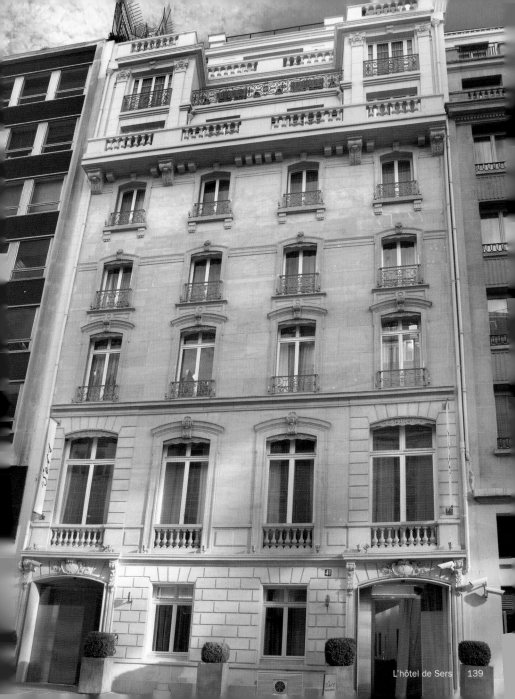

L'hôtel de Sers

41, av. Pierre-Premier-de-Serbie
75008 Paris
Champs-Elysées
Phone: +33 1 53 23 75 75
Fax: +33 1 53 23 75 76
www.hoteldesers.com

Cool Restaurants nearby:
Maison Blanche
6 New York
Alain Ducasse au Plaza Athénée

Cool Shops nearby:
Louis Vuitton
Dolce & Gabbana

Price category: €€€
Rooms: 52
Facilities: Restaurant, S'Bar, fitness room, sauna and hammam, massages, bath menu, conference room
Services: Massages on request in guestroom
Located: Only steps away from the Champs-Elysées
Métro: 1 George V
Map: No. 26
Style: Contemporary design
What's special: This property is a fine combination of classic Parisian architecture with cutting-edge interior design. Guestrooms feature by designed furniture for the hotel; on the top floors find 2 superb Panoramic suites with outdoor terraces and jaw-dropping city views.

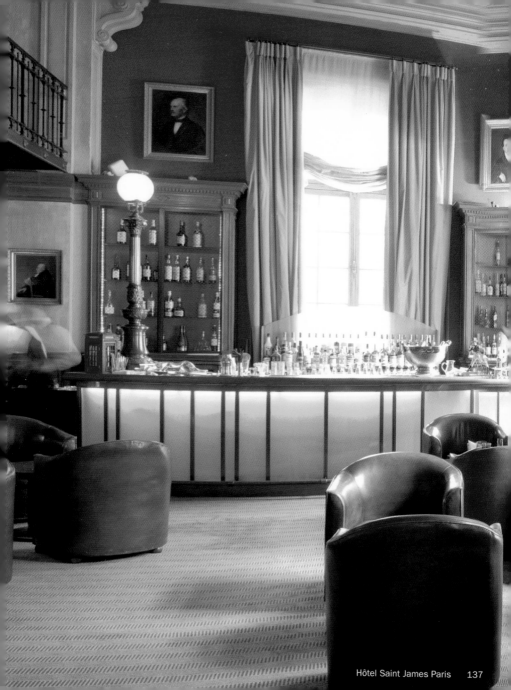

The Five Hotel

3, rue Flatters
75005 Paris
Quartier Latin
Phone: +33 1 43 31 74 21
www.thefivehotel.com

Cool Restaurants nearby:
Café de Flore
Brasserie Lipp

Cool Shops nearby:
Fresh
Orizzonti

Price category: €€
Rooms: 24 rooms
Facilities: Lounge, bar
Services: Babysitting/child services, disabled accessible
Located: In the heart of the historical Paris, next to Notre-Dame, the Panthéon and the Jardin des Plantes
Métro: 7 Les Gobelins; 7 Censier Daubenton; RER B Port Royal
Map: No. 8
Style: Contemporary design
What's special: Solid vivid colors, walls gleaming with the texture of Chinese lacquer, tiny pinhole stars floating up the walls and onto the ceiling of this small futuristic boutique hotel. Some rooms feature platform-style beds suspended from the ceiling.

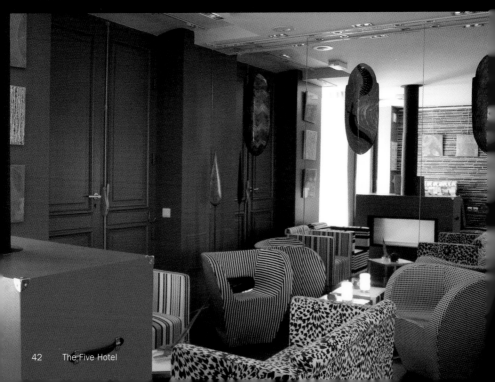

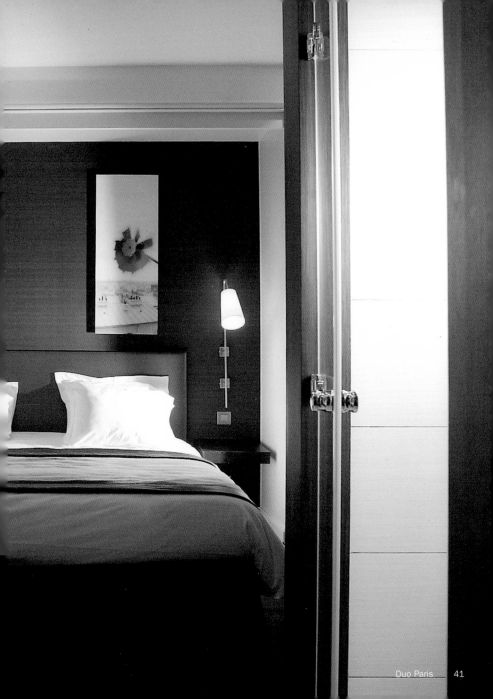

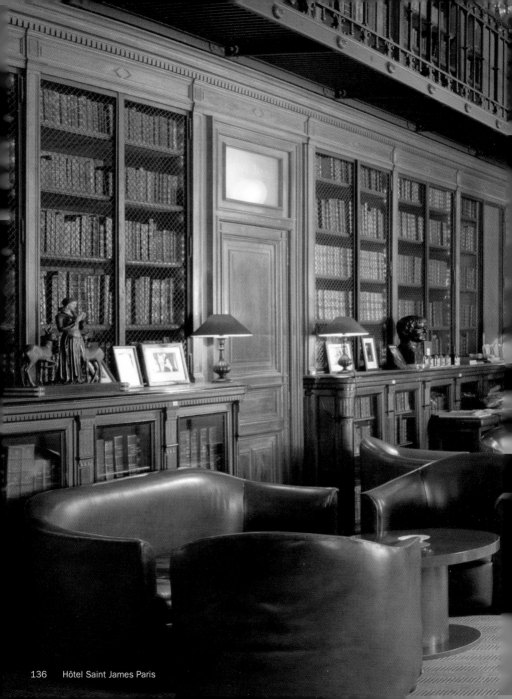

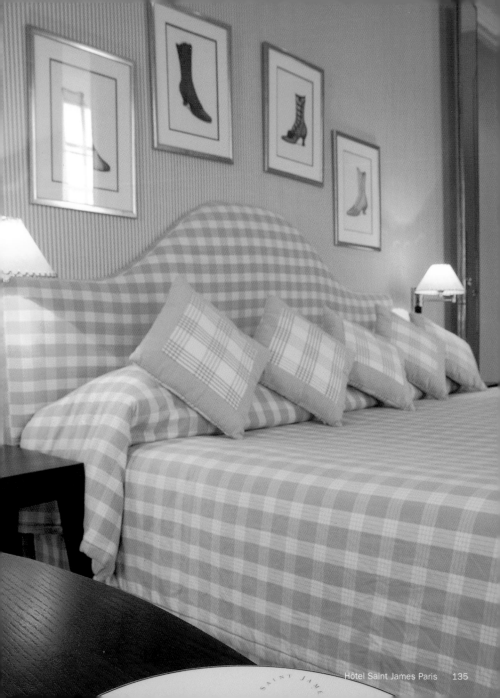

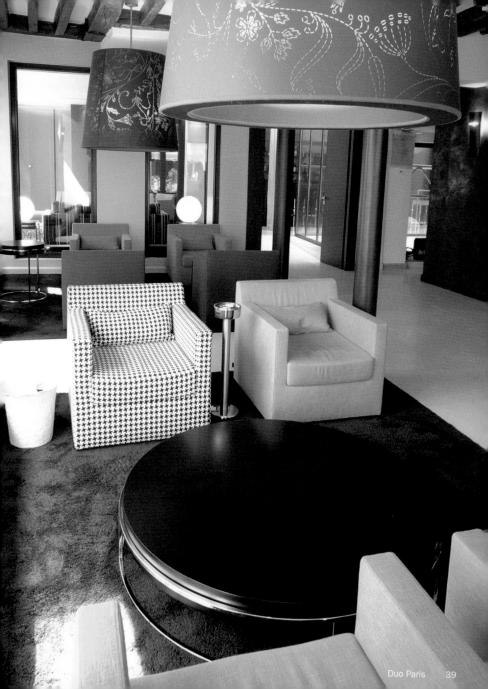

Hôtel Saint James Paris

43, avenue Bugeaud
75116 Paris
16e Arrondissement
Phone: +33 1 44 05 81 81
Fax: +33 1 44 05 81 82
www.saint-james-paris.com

Cool Restaurants nearby:
Café de l'Homme
The Cristal Room Baccarat
Tokyo Eat Palais de Tokyo

Cool Shops nearby:
Gucci
Louis Vuitton

Price category: €€€
Rooms: 48 rooms and suites
Facilities: Restaurant, library bar, well-appointed health club with treadmills, stair masters, jacuzzi and saunas, meeting rooms
Services: Babysitter, massage, hairdresser
Located: Just a few minutes from the Arc de Triomphe, Champs-Elysées and Trocadéro
Métro: 2, RER C Porte Dauphine
Map: No. 25
Style: Modern classic
Special features: This beautiful 19th century château combines majestic architecture with the understated atmosphere of a private club. Its 48 bedrooms and suites were individually decorated with the rooms on the top floor having their own interior patios.

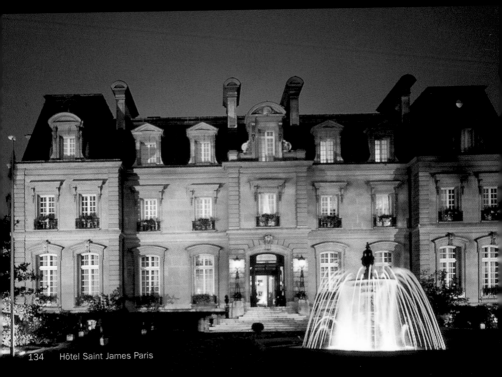

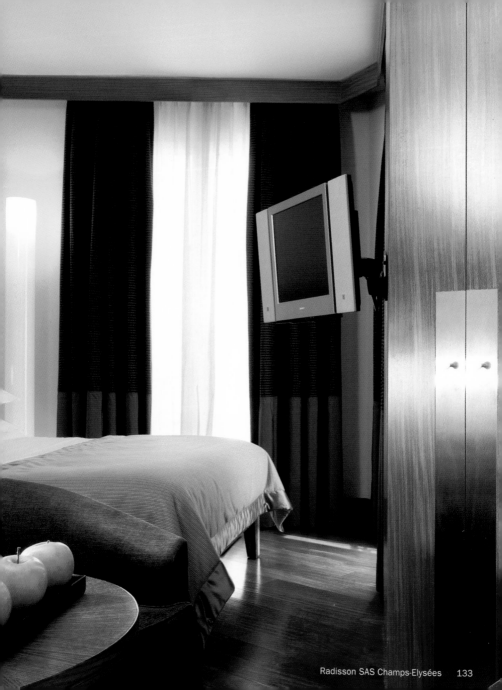

Duo Paris

11, rue du Temple
75004 Paris
Le Marais
Phone: +33 1 42 72 72 22
Fax: +33 1 42 72 03 53
www.duoparis.com

Cool Restaurants nearby:
Café Marly
Kong
Georges

Cool Shops nearby:
Calligrane
A-Poc Space
L'Atelier du Savon

Price category: €
Rooms: 58 rooms and suites
Facilities: Bar, fitness room, sauna
Services: Disabled accessible
Located: In the Marais, few steps away from Beaubourg
Métro: 1, 11 Hôtel de Ville
Map: No. 7
Style: Contemporary design
What's special: A chic and intimate atmosphere defines the place in symbiosis with its neighborhood, between the popular Marais and Beaubourg area, where passed times and memories cohabit with today's modernity, culture and entertainment.

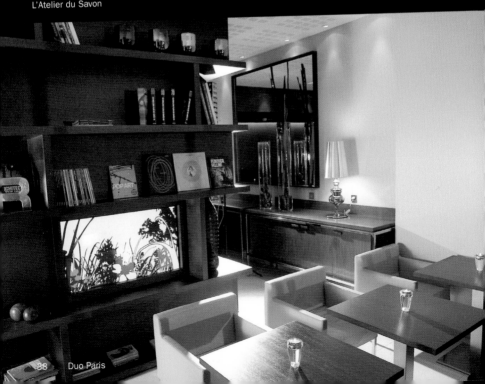

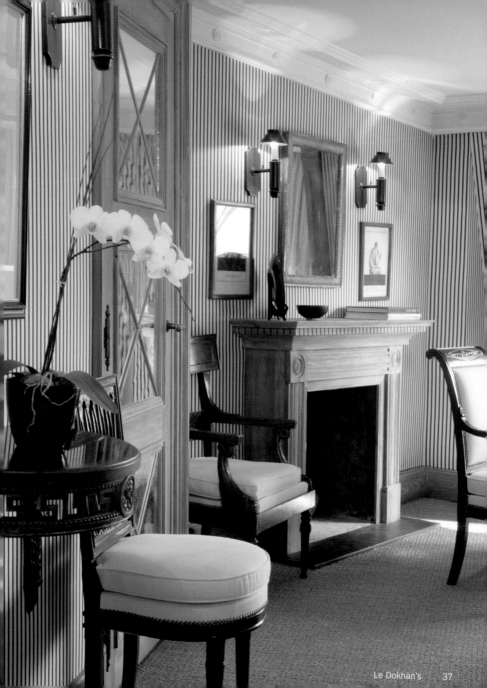

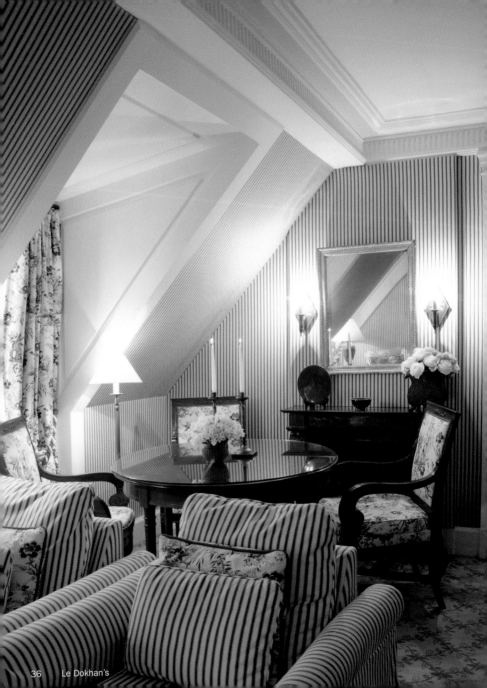

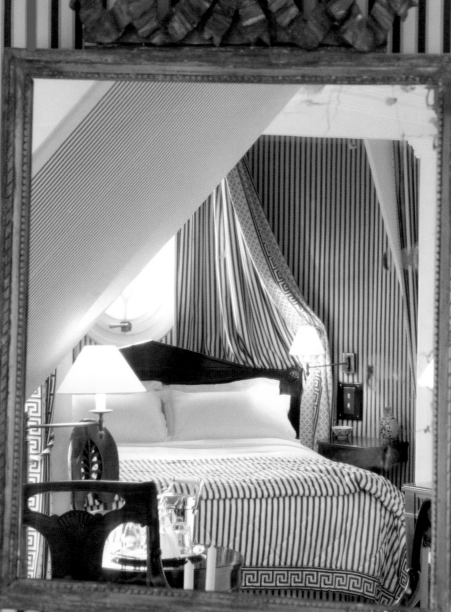

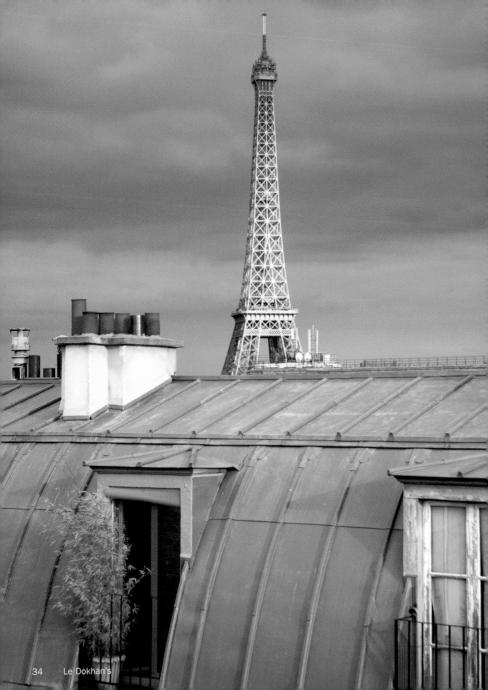

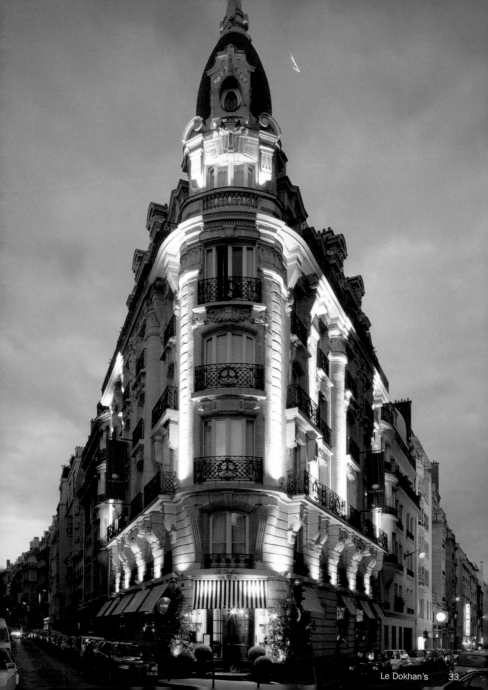

Le Dokhan's

117, rue Lauriston
75116 Paris
16e Arrondissement
Phone: +33 1 53 65 66 99
Fax: +33 1 53 65 66 88
www.dokhans-sofitel-paris.com

Cool Restaurants nearby:
Café de l'Homme
The Cristal Room Baccarat
Tokyo Eat Palais de Tokyo

Cool Shops nearby:
Jean-Paul Gaultier
Gucci

Price category: €€€
Rooms: 41 rooms, 4 suites
Facilities: Champagne-Bar
Services: Dogs allowed
Located: Located between the Trocadéro and Arc de Triomphe
Métro: 6, 9 Trocadéro; 2, RER A Etoile and Victor Hugo
Map: No. 6
Style: Classic elegance
What's special: The Haussmann style mansion is the temple to luxury with neo-classical décor and antique furniture. It features the only champagne bar in Paris to also offer light meals.

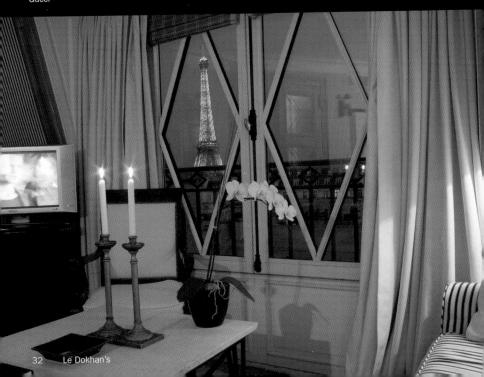

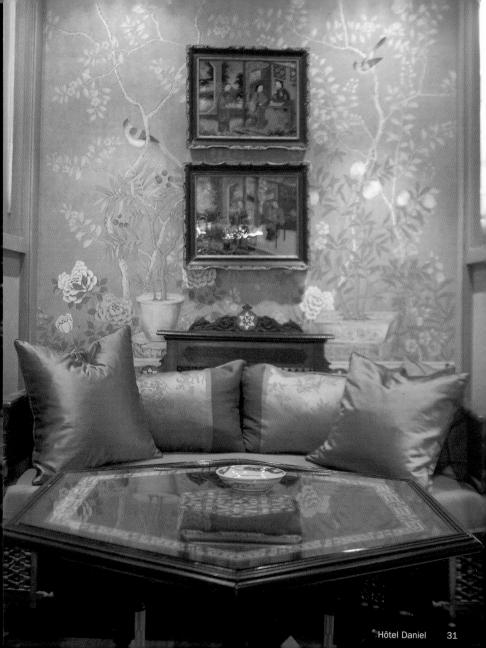

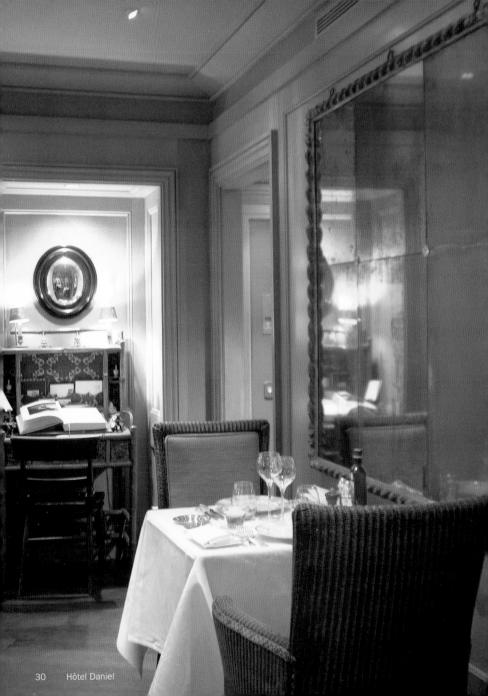

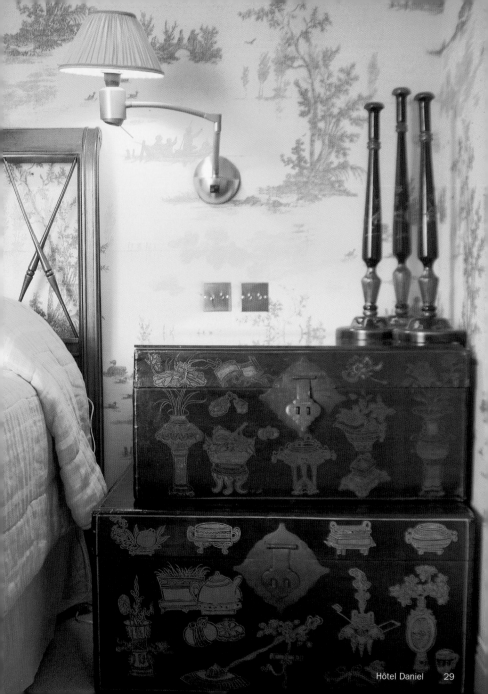

Hôtel Daniel

8, rue Frédéric-Bastiat
75008 Paris
Champs-Elysées
Phone: +33 1 42 56 17 00
Fax: +33 1 42 56 17 01
www.hoteldanielparis.com

Cool Restaurants nearby:
Lô Sushi
La Suite
Mandala Ray

Cool Shops nearby:
Peugeot Avenue
Jean-Paul Gaultier

Price category: €€€
Rooms: 26 rooms including 9 suites
Facilities: Award winning gourmet restaurant, lounge and tea-room
Services: Valet parking, disabled accessible
Located: A few steps away from the Champs-Elysées and Rue du Faubourg Saint-Honoré
Métro: 9 Saint-Philippe-du-Roule
Map: No. 5
Style: Classic elegance
What's special: The interior design of this luxurious Relais & Châteaux hotel is decorated in the style of the XVIII century and inspired by French, Middle East and the Far East. Its sumptuous fabrics and antique furniture recall the silk route throughout the elegantly suites, rooms and reception area.

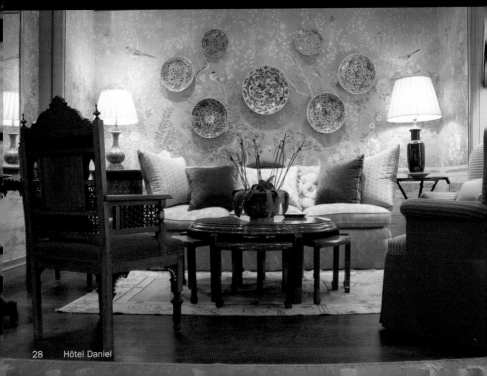

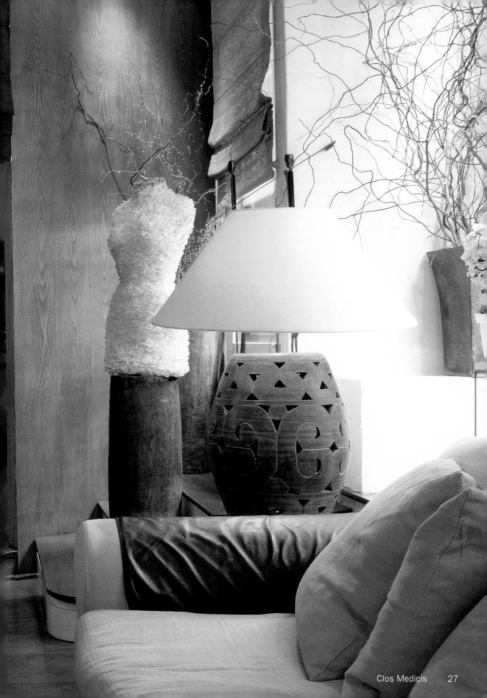

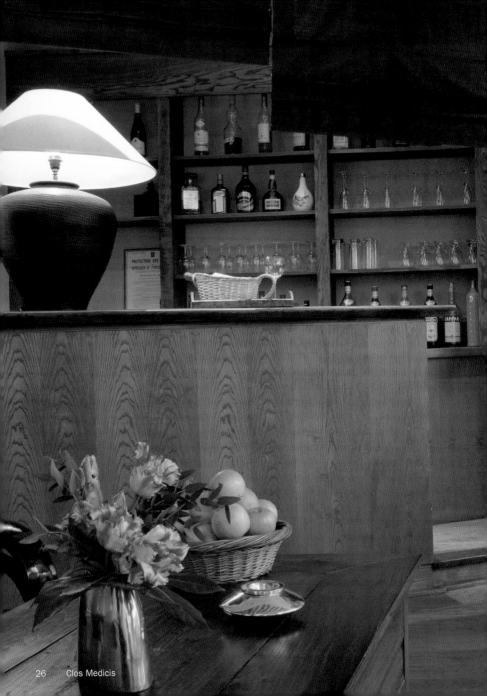

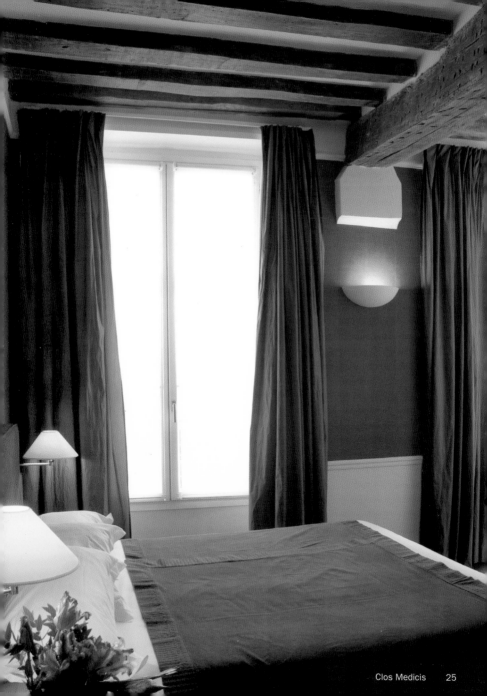

Clos Medicis

56, rue Monsieur-Le-Prince
75006 Paris
Saint-Germain-des-Prés
Phone: +33 1 43 29 10 80
Fax: +33 1 43 54 26 90
www.closmedicis.com

Cool Restaurants nearby:
Café de Flore
Brasserie Lipp

Cool Shops nearby:
Au nom de la rose
Orizzonti
Fresh

Price category: €€
Rooms: 38 rooms
Facilities: Bar-lounge, buffet breakfast served in the garden in summertime
Services: Free Internet access
Located: Between Saint-Germain-des-Prés and the Quartier Latin, a few steps from the Jardin du Luxembourg
Métro: 4, 10 Odéon
Map: No. 4
Style: French Country
What's special: Charming, privately-owned boutique-hotel on the Rive Gauche offers a cozy lounge with antique furnishings and a lovely fireplace. The contemporary-style furbished interior and the inner courtyard provides a country feeling in the middle of urban life.

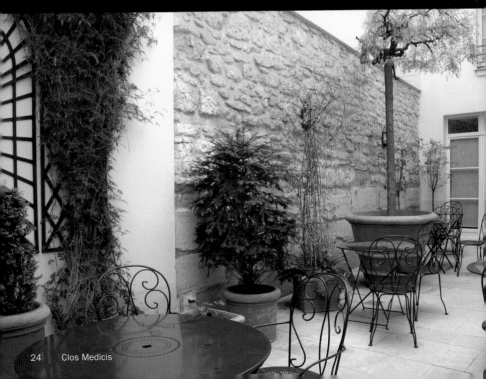

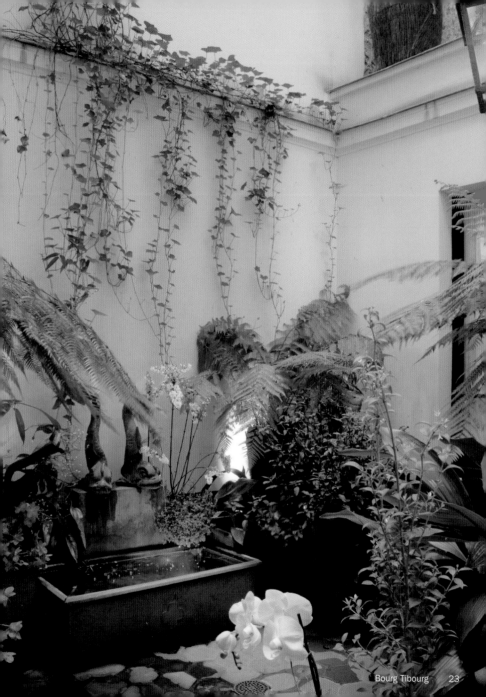

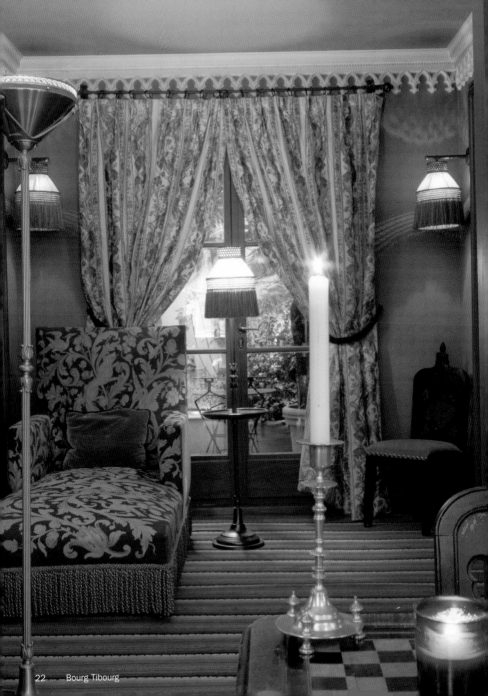

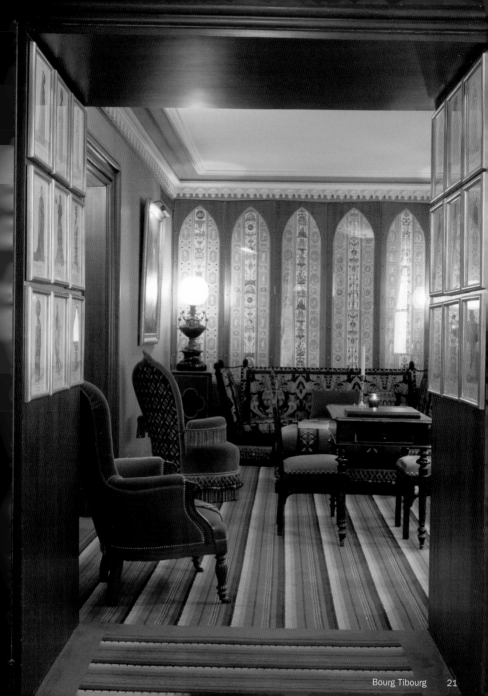

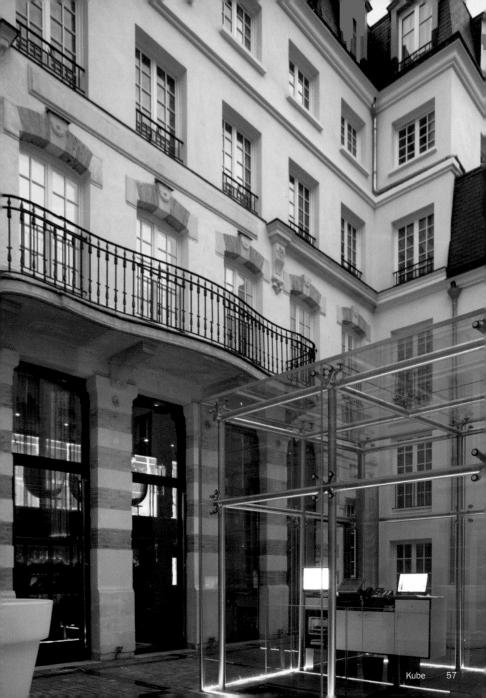

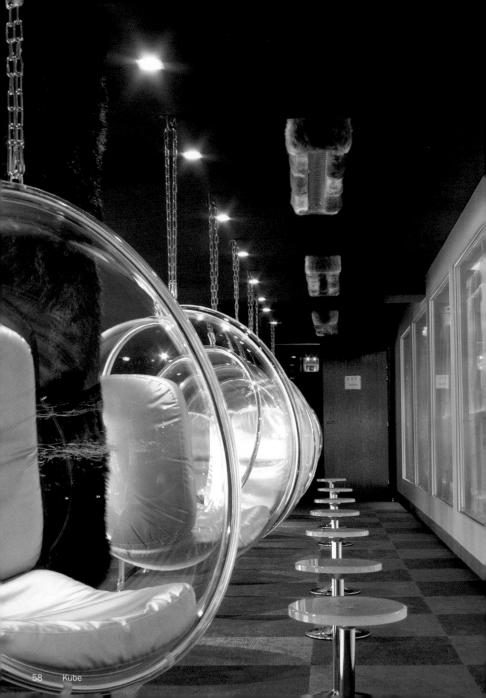

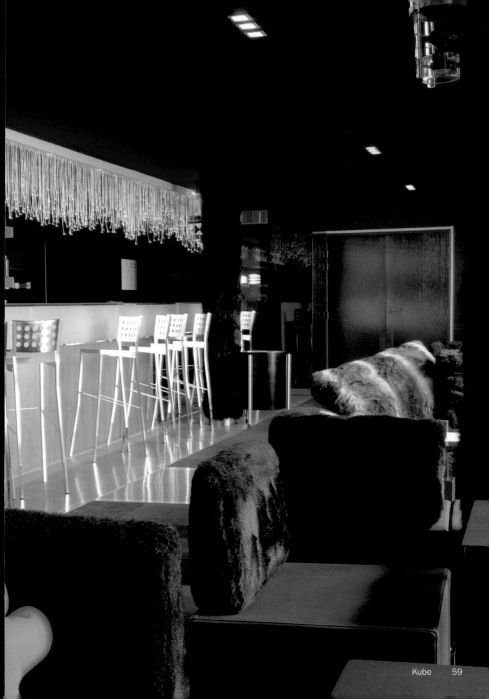

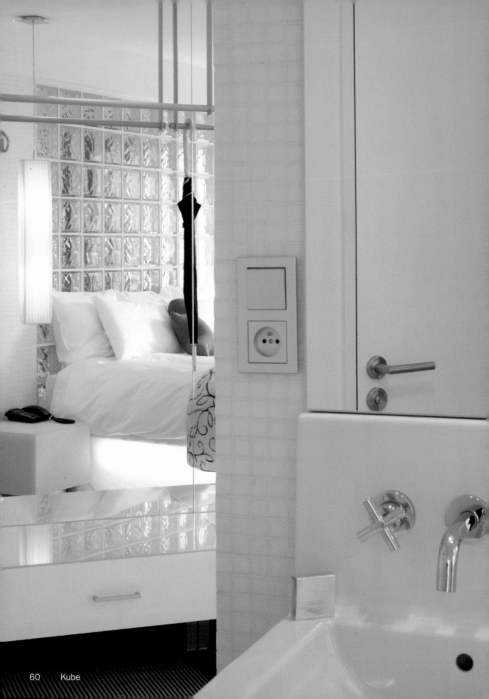

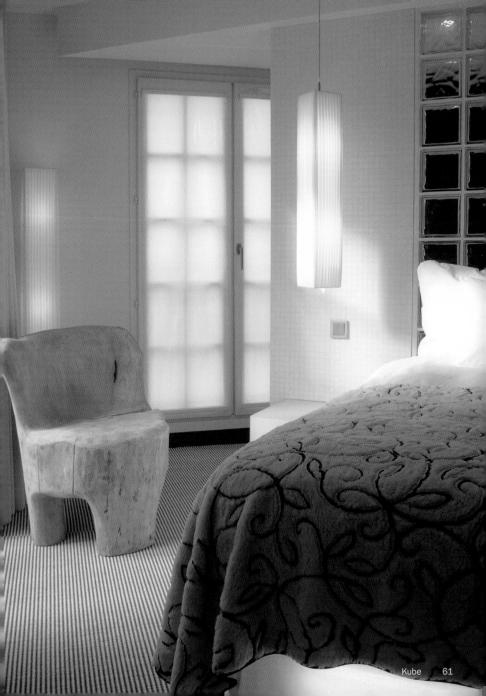

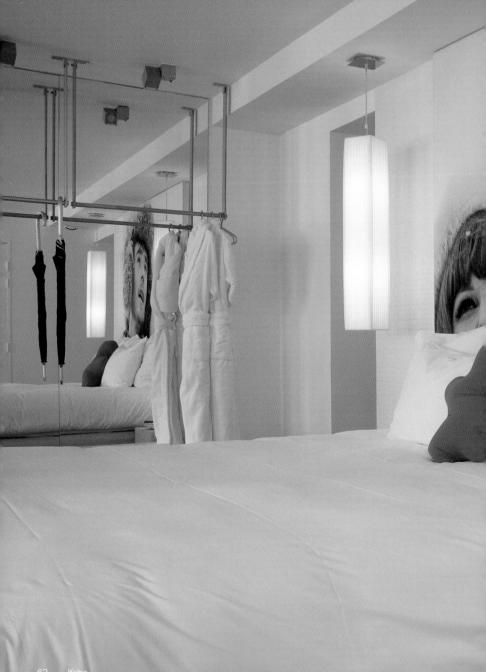

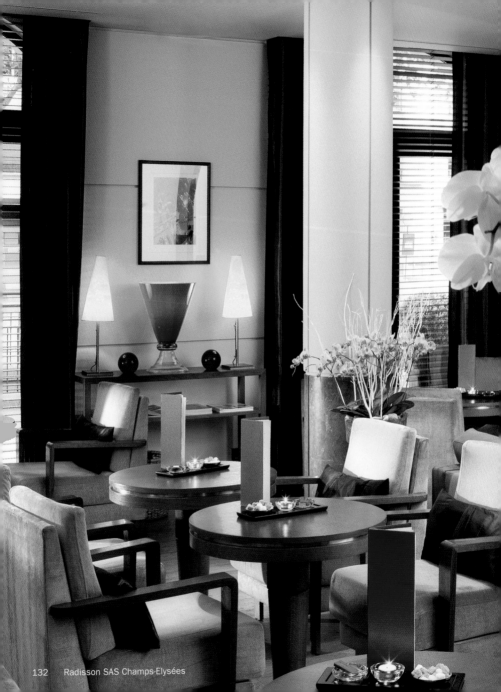

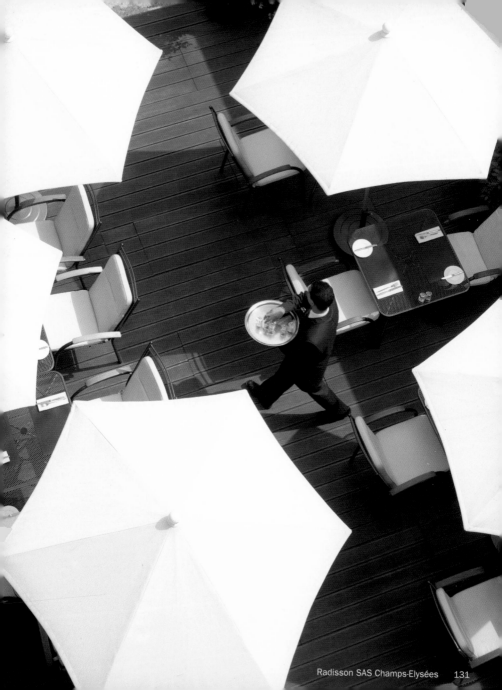

Radisson SAS Champs-Elysées

78 bis, avenue Marceau
75008 Paris
Champs-Elysées
Phone: +33 1 53 23 43 43
Fax: +33 1 53 23 43 44
www.champselysees.paris.
radissonsas.com

Cool Restaurants nearby:
La Suite
Mandala Ray
The Cristal Room Baccarat

Cool Shops nearby:
Jean-Paul Gaultier
Peugeot Avenue

Price category: €€€
Rooms: 46 including 1 suite
Facilities: Restaurant La Place, lounge, bar, meeting-room
Services: Golden Key concierge, free Internet access, parking for 8 cars
Located: Next to the Champs-Elysées and the Arc de Triomphe
Métro: 1, RER A Etoile
Map: No. 24
Style: Contemporary design
What's special: The former headquarters of Louis Vuitton now houses a contemporary and elegant hotel. Rooms and suites feature stylish modern decor, distinctive artwork and neutral colors.

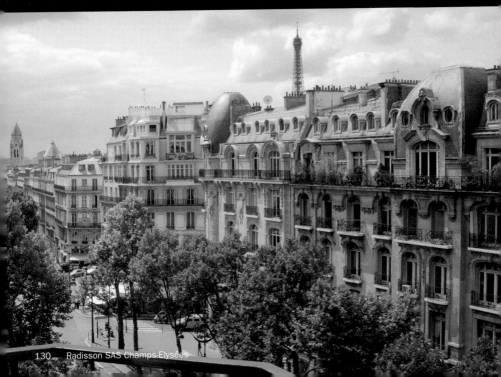

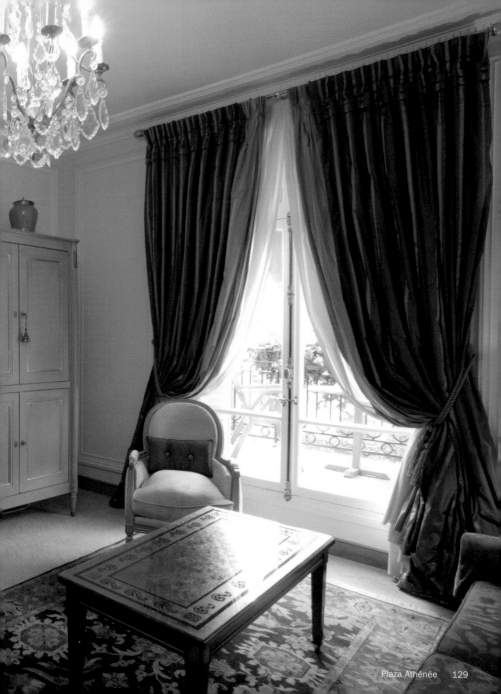

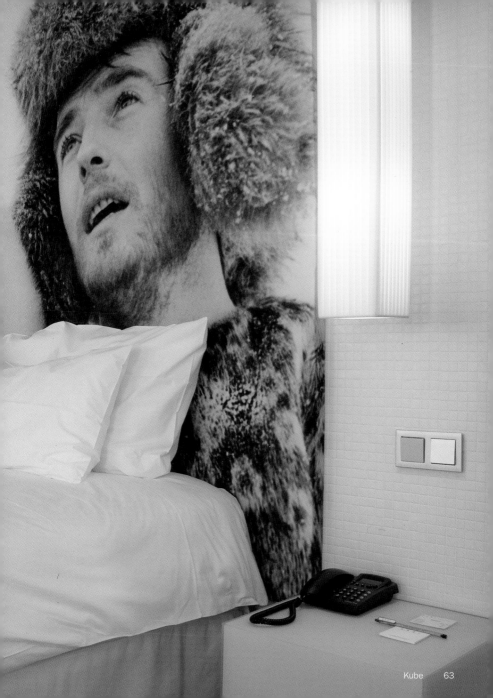

Le A

4, rue d'Artois
75008 Paris
Champs-Elysées
Phone: +33 1 42 56 99 99
Fax: +33 1 42 56 99 90
www.hotel-le-a-paris.com

Price category: €€€
Rooms: 26 rooms and suites
Facilities: Bar lounge
Services: Internet access, buffet breakfast
Located: Near Champs-Elysées
Métro: 9 Saint-Philippe-du-Roule
Map: No. 12
Style: Contemporary design
What's special: The black-and-white decor of this smart designer hotel is a backdrop for the models, artists and media types in the lounge bar area; splashes of color come from conceptual artist Fabrice Hybert.

Cool Restaurants nearby:
Lô Sushi
La Suite
Mandala Ray

Cool Shops nearby:
Peugeot Avenue
Jean-Paul Gaultier

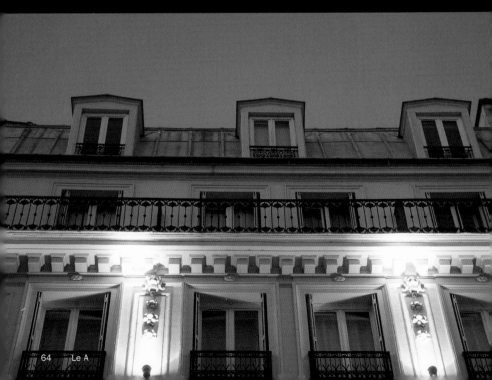

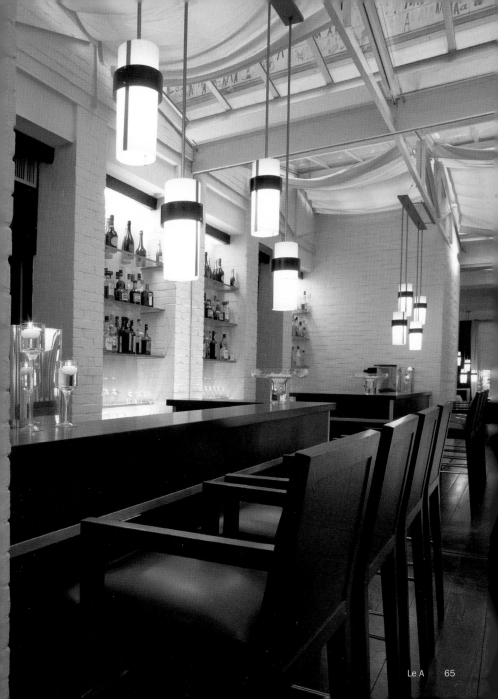

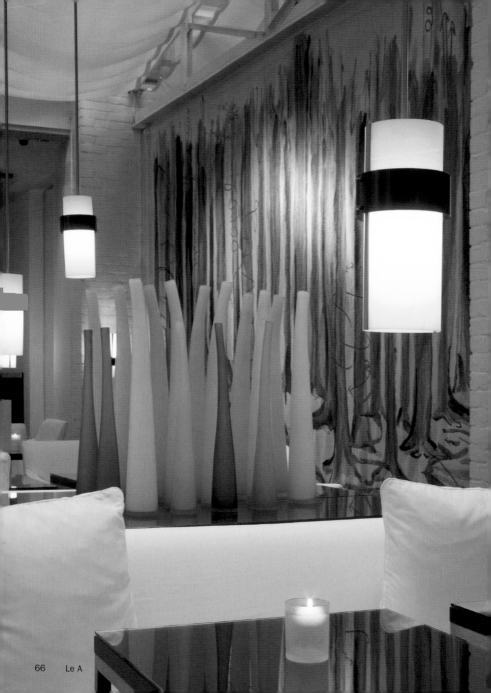

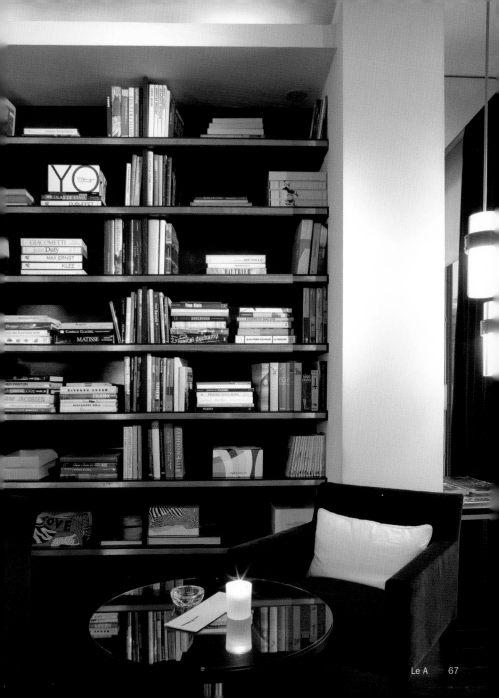

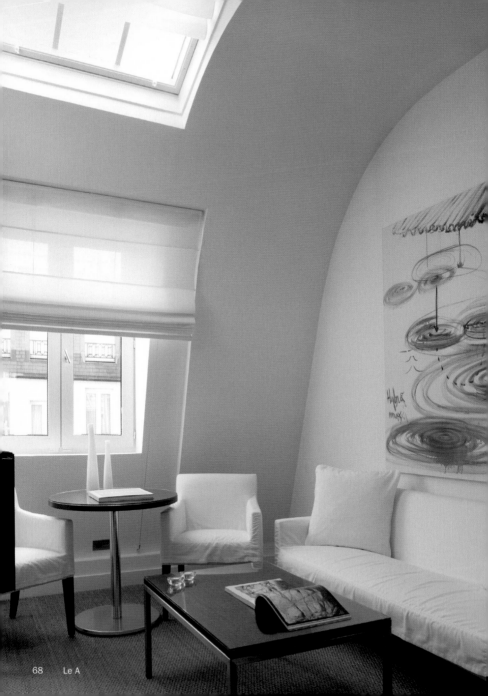

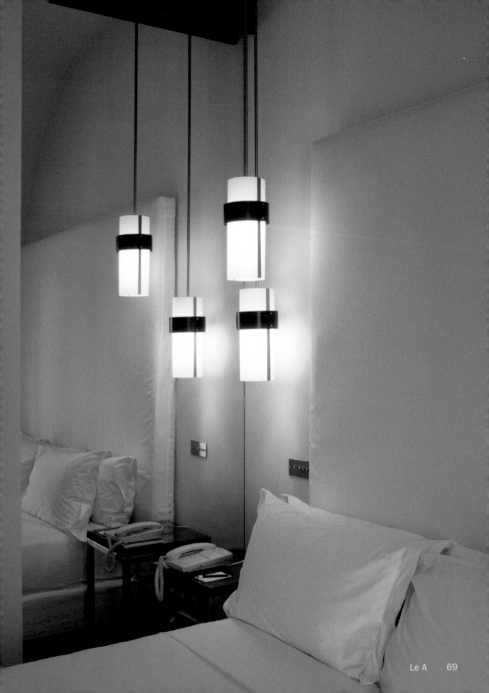

13, rue des Beaux-Arts
75006 Paris
Saint-Germain-des-Prés
Phone: +33 1 44 41 99 00
Fax: +33 1 43 25 64 81
www.l-hotel.com

Cool Restaurants nearby:
Café Marly
Kong
Café de Flore
Brasserie Lipp

Cool Shops nearby:
Les Salons du Palais Royal Shiseido
Knoll International

Price category: €€€
Rooms: 20
Facilities: Restaurant, bar, replica roman bath, hammam, relaxing room
Services: Free Internet access, spa treatments in room, worldwide newspapers printed and delivered on demand
Located: Located in the heart of Paris' famous and historic Rive Gauche
Métro: 4 Saint-Germain-des-Prés
Map: No. 13
Style: Cosy and romantic
What's special: It is a sanctuary of tranquility and luxury. Renowned designer Jacques Garcia redecorated the iconic hotel where Oscar Wilde lived until the end of his life by retaining its Victorian-baroque sense, adding a swimming pool and a hammam under the old vault of the building.

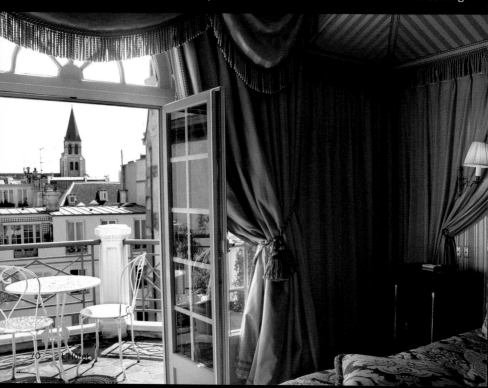

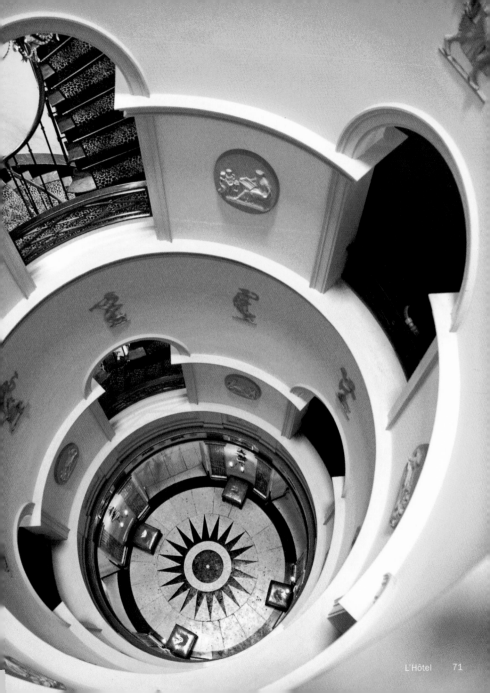

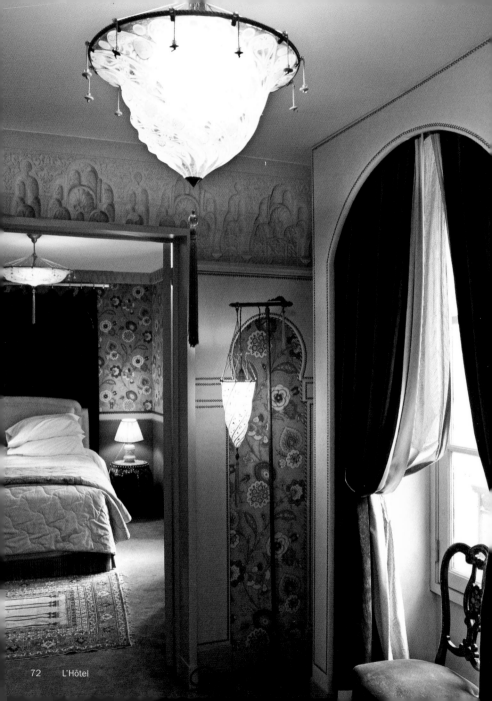

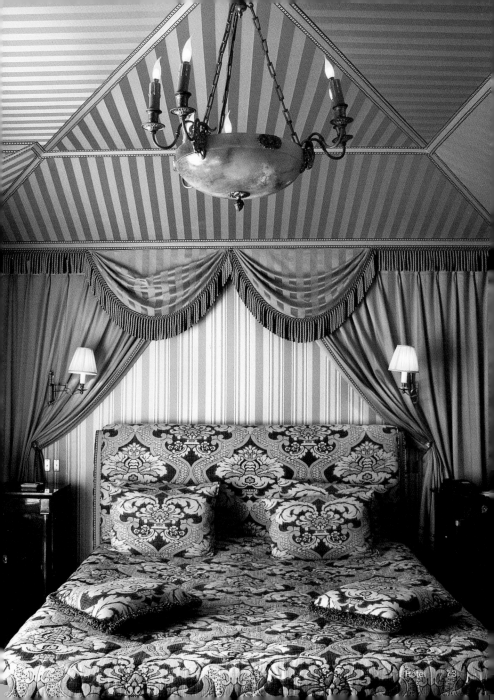

4, rue Salomon-de-Caus
75003 Paris
3e Arrondissement
Phone: +33 1 42 72 08 15
Fax: +33 1 42 72 45 81
www.littlepalacehotel.com

Cool Restaurants nearby:
Etienne-Marcel
Georges
Murano

Cool Shops nearby:
Antoine et Lili
Galerie Dansk

Price category: €€
Rooms: 53
Facilities: Restaurant, bar
Services: Transfers from stations and airports, small pets are allowed
Located: 10 minutes to the Louvre, Notre Dame and Centre Pompidou
Métro: 3, 4 Réaumur-Sébastopol
Map: No. 14
Style: Art Deco
What's special: This early 20th century property was restored and decorated in an elegant neo-classical style with marble carvings and wrought iron balconies and offset by the comfort that pervades the guestrooms, each decorated with contemporary furnishings and soft pastel hues.

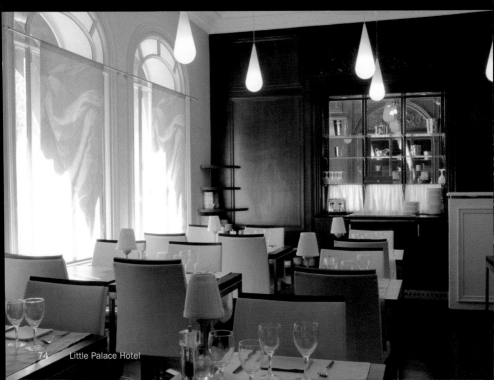

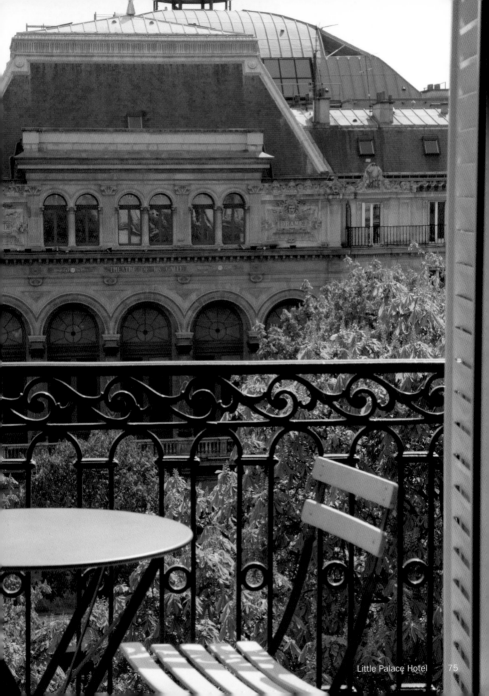

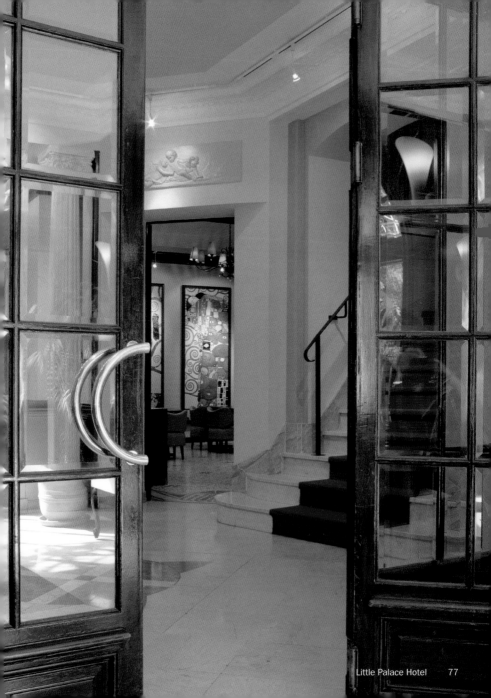

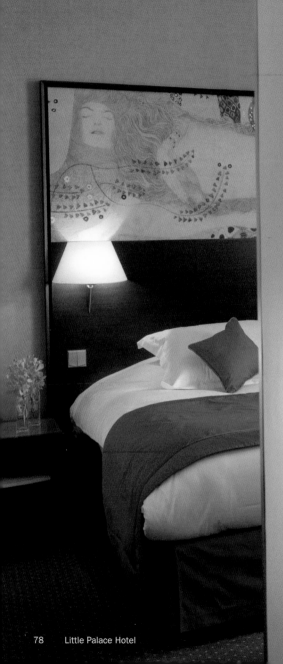

Mayet

3, rue Mayet
75006 Paris
6e Arrondissement
Phone: +33 1 47 83 21 35
Fax: +33 1 40 65 95 78
www.mayet.com

Cool Restaurants nearby:
Brasserie Lipp
Café de Flore

Cool Shops nearby:
Fresh
Orizzonti

Price category: €
Rooms: 23 rooms
Facilities: Bar
Services: Pets accepted
Located: In a small quiet street in the Invalides district
Métro: 10, 13 Duroc
Map: No. 15
Style: Contemporary design
What's special: A fresh, contemporary boutique hotel packs a punch for its budget-conscious guests. The lobby, decorated by Parisian graffiti artist Monsieur André adds to the youthful and fun ambience. Minimalist furnishings punctuated by splashes of bright color, cartoon-like accessories and snow-white duvet comforters.

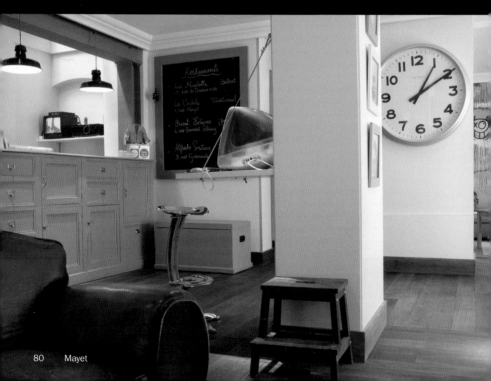

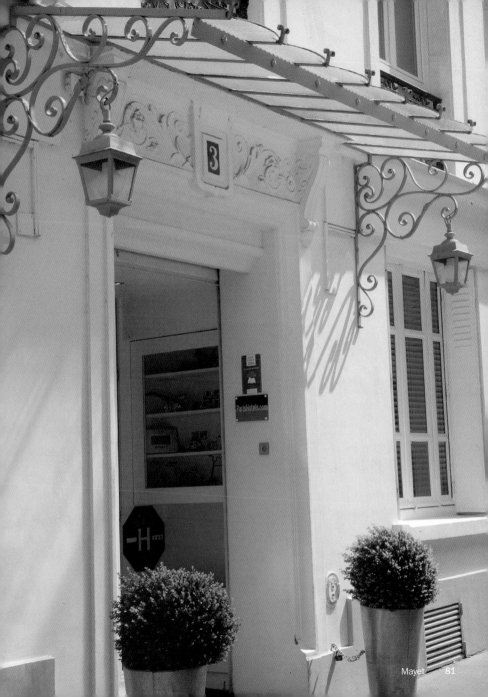

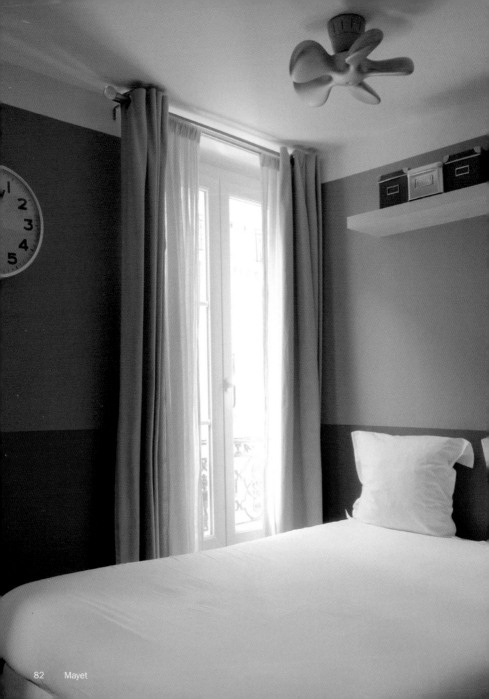

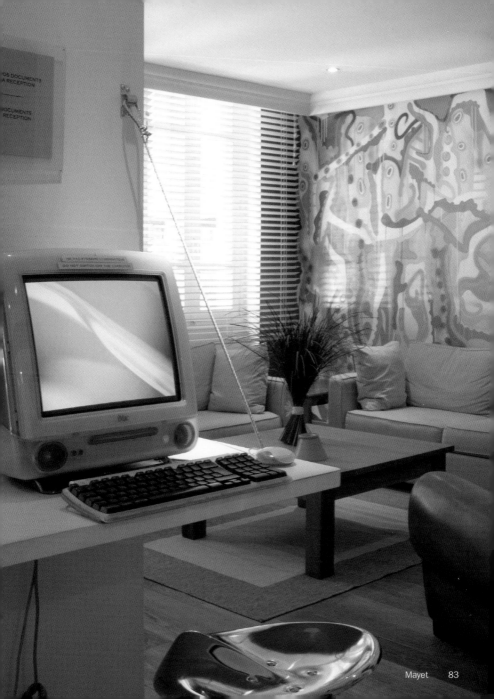

Le Meurice

228, rue de Rivoli
75001 Paris
1er Arrondissement
Phone: +33 1 44 58 10 10
Fax: +33 1 44 58 10 15
www.meuricehotel.com

Cool Restaurants nearby:
Water Bar Colette

Cool Shops nearby:
Michel Perry
Boutique John Galliano
Chantal Thomass

Price category: €€€€
Rooms: 160 rooms, 36 suites
Facilities: 2 restaurants, bar, sauna, hammam, jacuzzi, fitness room
Services: Secretarial services, children's program, complimentary high-speed Internet access in all rooms
Located: Facing the Tuileries Garden, between Place de la Concorde and the Louvre
Métro: 1 Tuileries; 1, 12 Concorde
Map: No. 16
Style: Classic elegance
What's special: This legendary hotel embodies the rebirth of a French landmark with exceptional style and quality combined with contemporary chic. Its guestrooms are decorated in a classic style (Louis XVI) with gracious 18th century furnishings and luxurious fabrics.

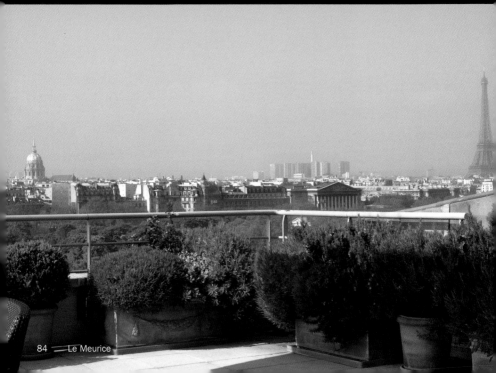

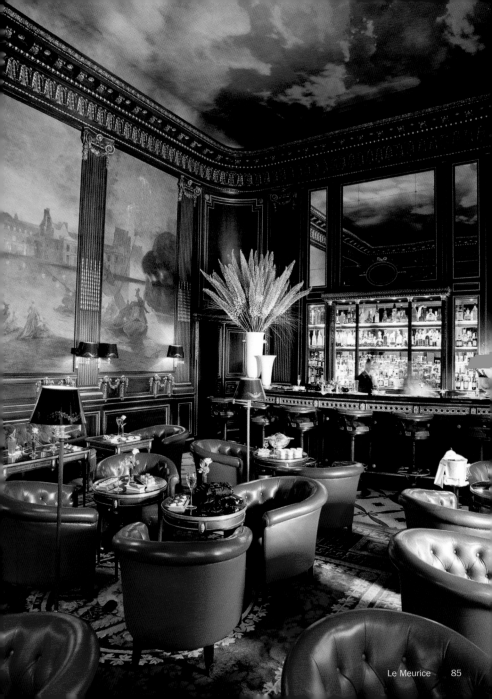

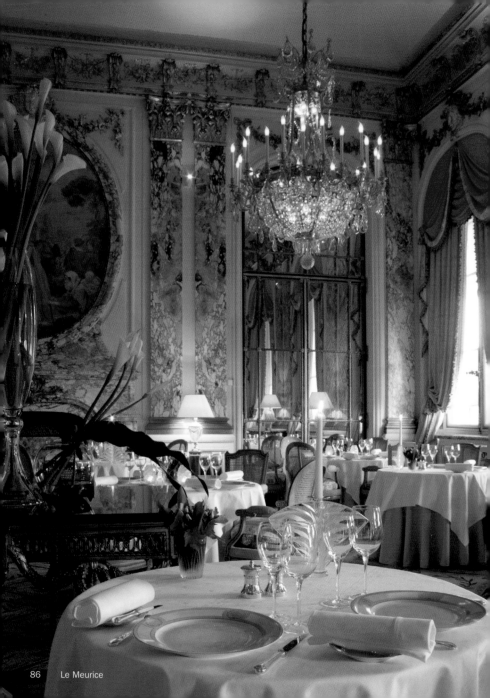

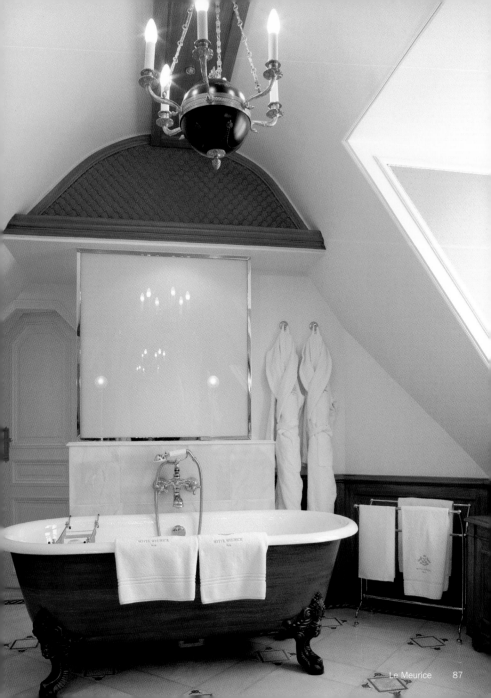

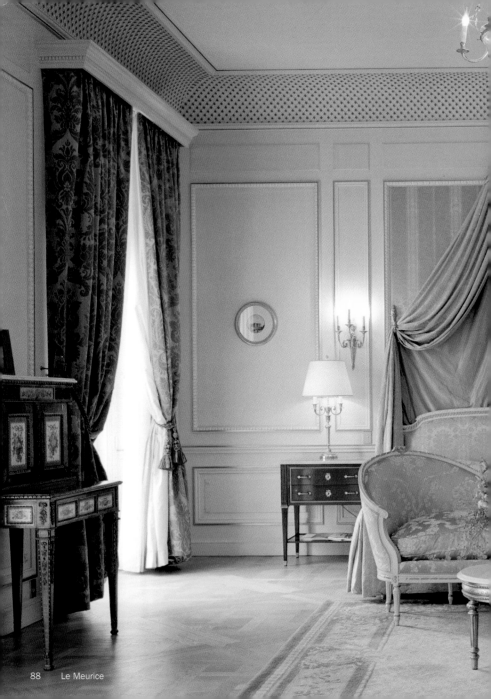

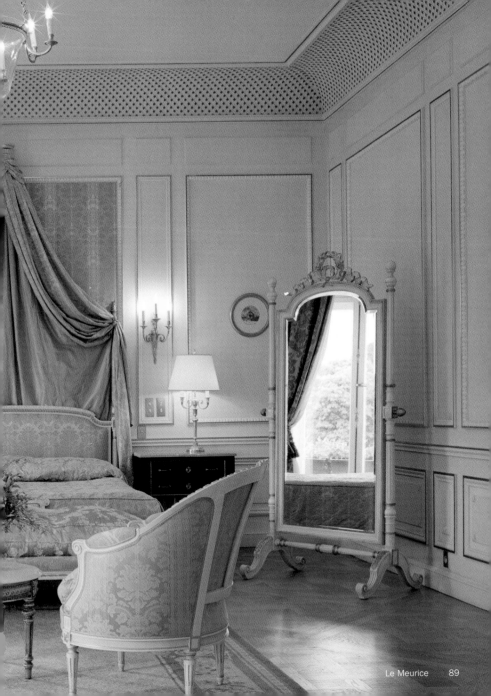

Montalembert

3, rue de Montalembert
75007 Paris
7e Arrondissement
Phone: +33 1 45 49 68 68
Fax: +33 1 45 49 69 49
www.montalembert.com

Cool Restaurants nearby:
Café de Flore
Brasserie Lipp
Arpège

Cool Shops nearby:
Artelano
Au nom de la rose
Knoll International

Price category: €€€€
Rooms: 56 including 8 suites
Facilities: Restaurant, lounge, bar, meeting rooms
Services: Children's program, friendly pets are welcome, limousine service
Located: Near by Musée d'Orsay and the Louvre
Métro: 12 Rue du Bac
Map: No. 17
Style: Contemporary design & modern classic
What's special: This is the epitome of Parisian spirit and style—innovative timeless chic hotel, offering a soothing palate of cinnamon, olive, lilac and taupe. Classic rooms feature Louis Philippe furniture and contemporary rooms are all decorated with dark wood furniture and black-and-white photographs.

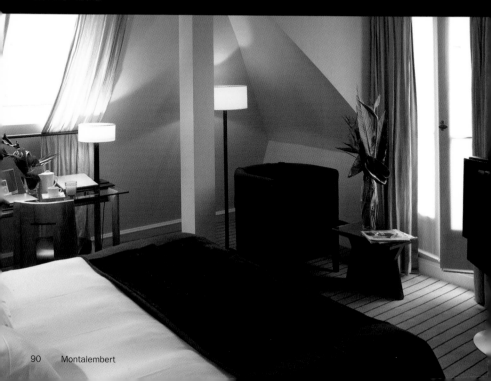

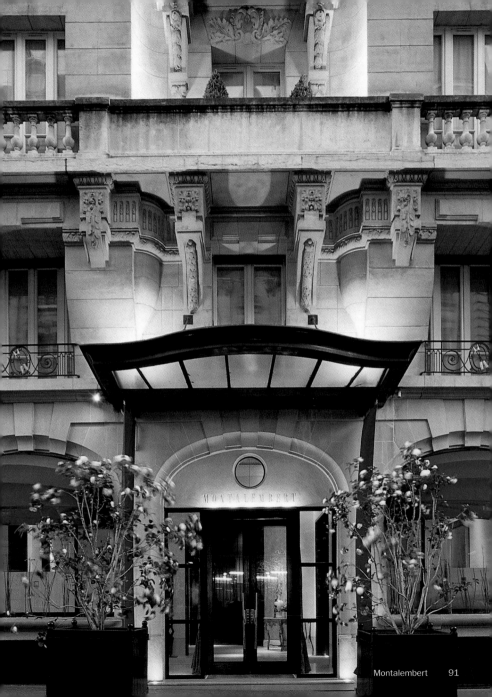

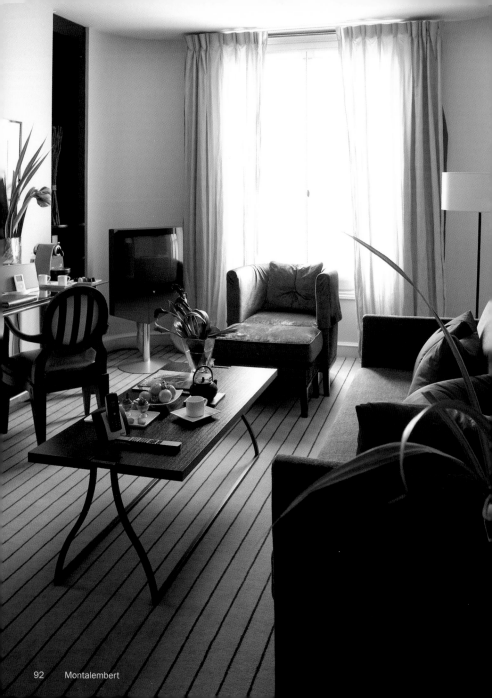

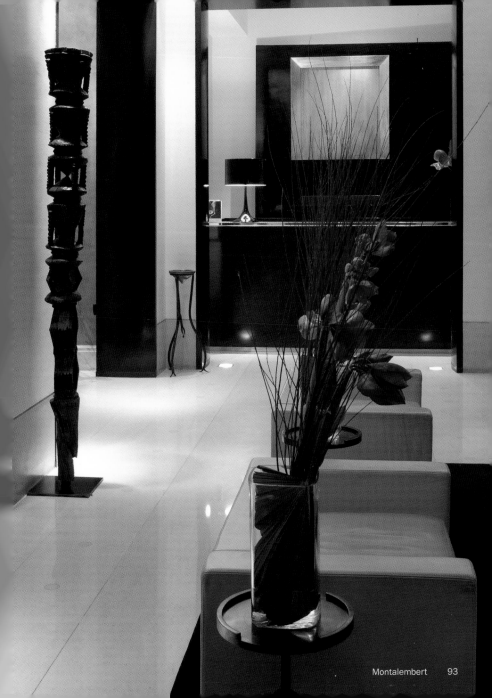

3e Arrondissement
Phone: +33 1 42 71 20 00
Fax: +33 1 42 71 21 01
www.muranoresort.com

Cool Restaurants nearby:
Murano
Georges
Chez Paul

Cool Shops nearby:
Galerie Dansk
Antoine et Lili

Facilities: Restaurant, piano bar, outdoor swimming pool, fitness center
Services: Pets allowed, babysitting/child services
Located: In the Marais district, one of the most stylish and hip areas of Paris
Métro: 8 Filles du Calvaire
Map: No. 18
Style: Contemporary design
What's special: This urban resort is a sensual delight of spectacular interior design: the bedrooms can be lit in 6 different colors to suit the mood, bathrooms are canvassed in black slate, and the fantastic lobby features a chesterfield sofa in white leather. Its decorative theme revolves around the transparency of Murano glass.

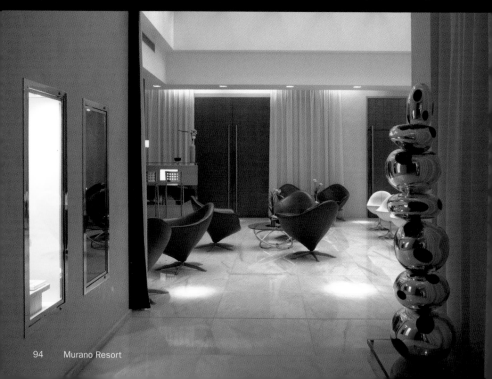

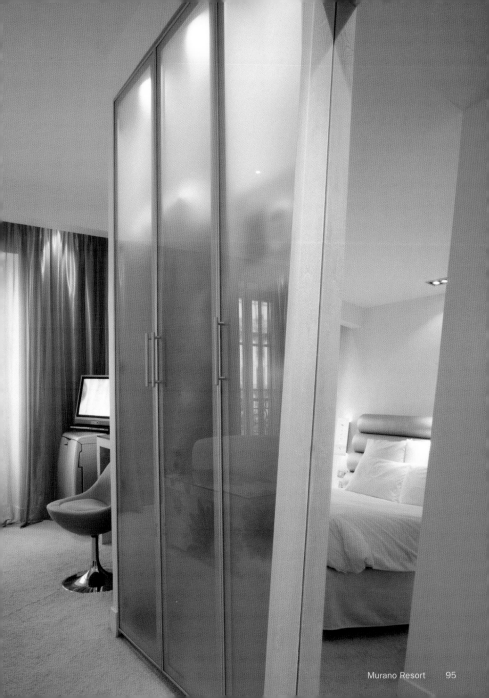

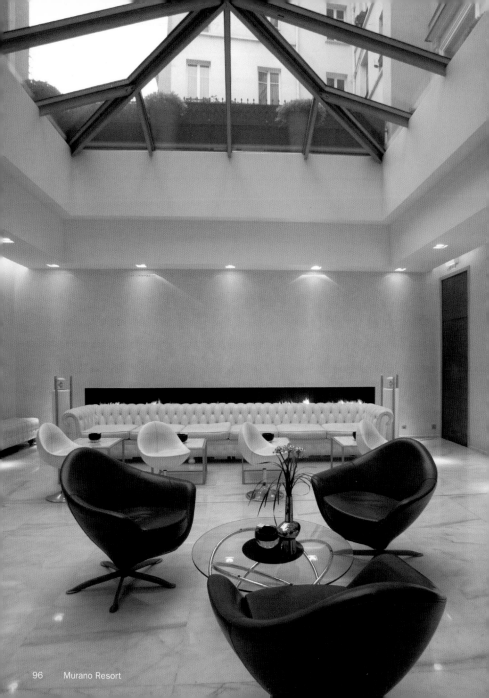

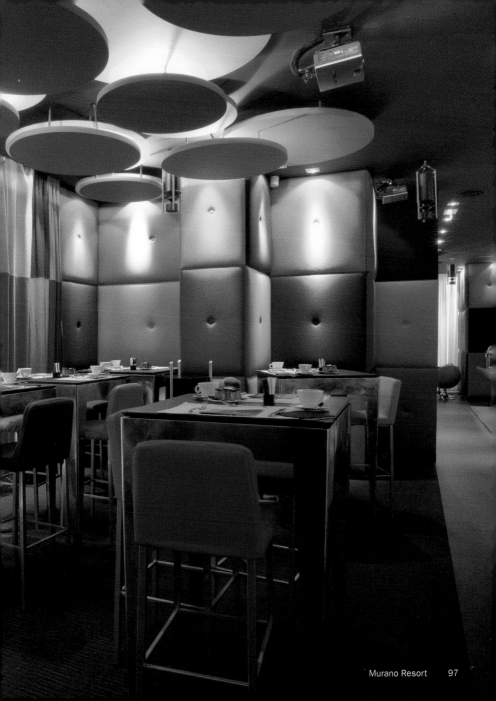

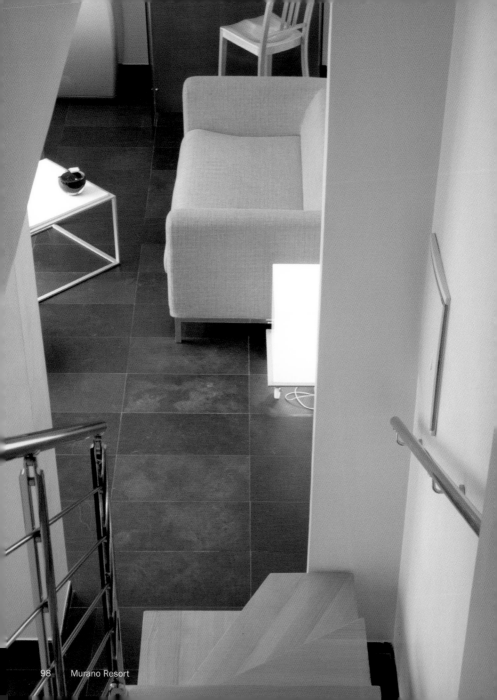

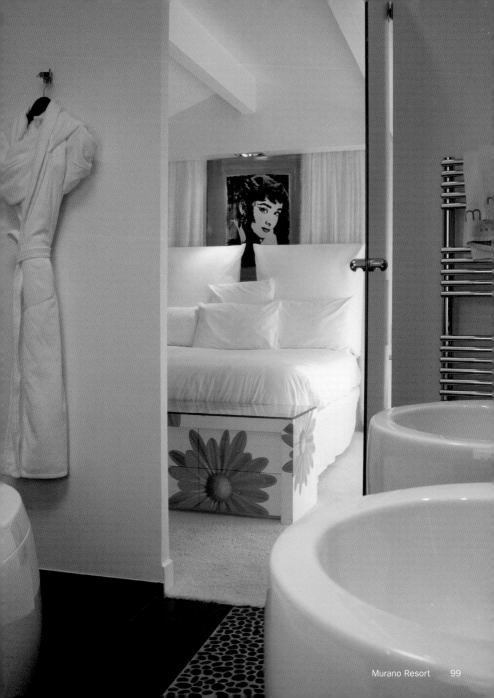

Park Hyatt Vendôme

5, rue de la Paix
75002 Paris
2e Arrondissement
Phone: +33 1 58 71 12 34
Fax: +33 1 58 71 12 35
www.paris.vendome.hyatt.com

Cool Restaurants nearby:
Harry's Bar
Bertie
Fontaine Gaillon

Cool Shops nearby:
Face à Face
Zero one one

Price category: €€€€
Rooms: 168 rooms including 36 suites
Facilities: Restaurants Le Pur'Grill, Les Orchidées, bar
La Terrasse, 8 meeting rooms, spa with gym
Services: Private parking, babysitting by prior arrangement,
Internet access
Located: Close to the Place Vendôme and Place de la Concorde
Métro: 3, 7, 8, RER A Opéra; 1, 8, 12 Concorde; 8, 12,
14 Madeleine; 7, 14 Pyramide
Map: No. 19
Style: Contemporary design
What's special: Architect Ed Tuttle has created a stream-
lined palace with exquisite decor finished in impeccable detail
with wood, taupe and cream fabrics and gold-silk curtains.
Original touches include "disappearing" sliding doors that
dramatically reveal the limestone and gilded-tap bathrooms.

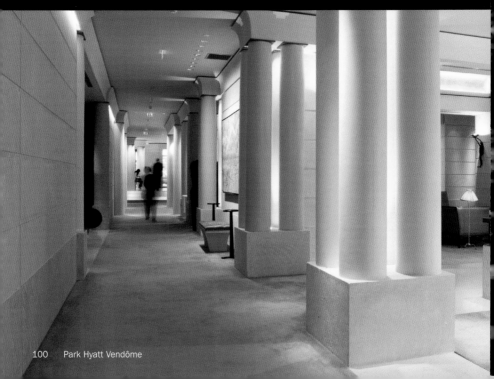

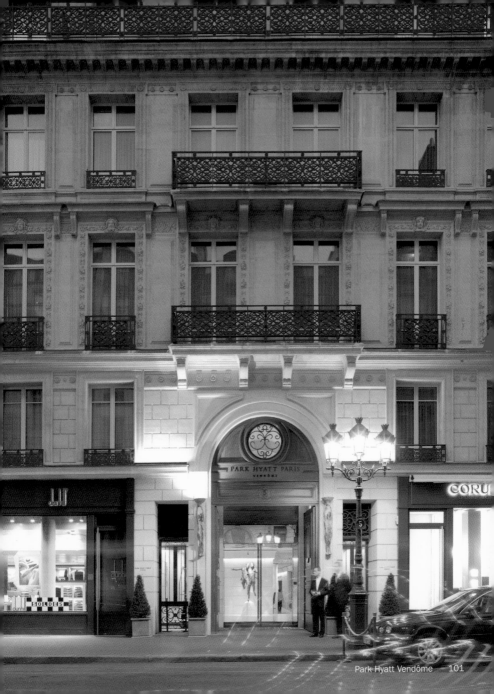

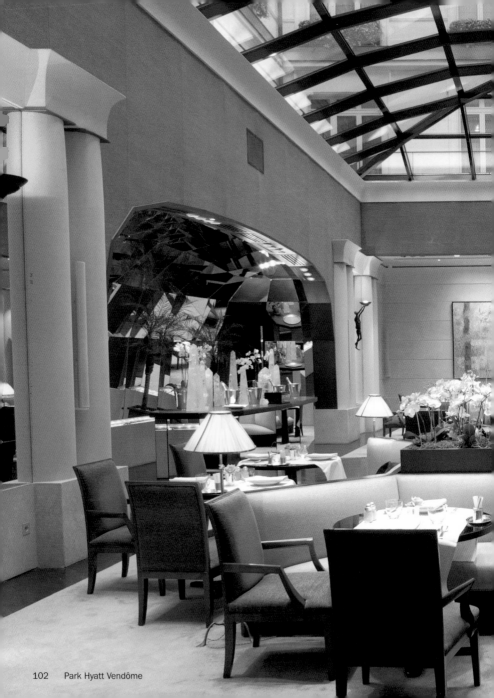

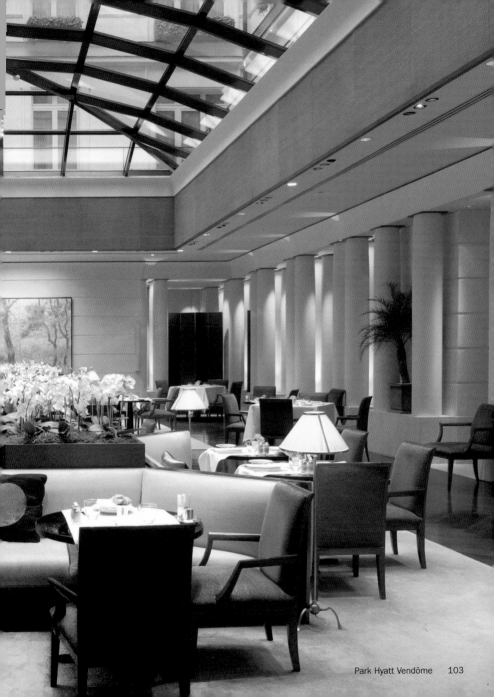

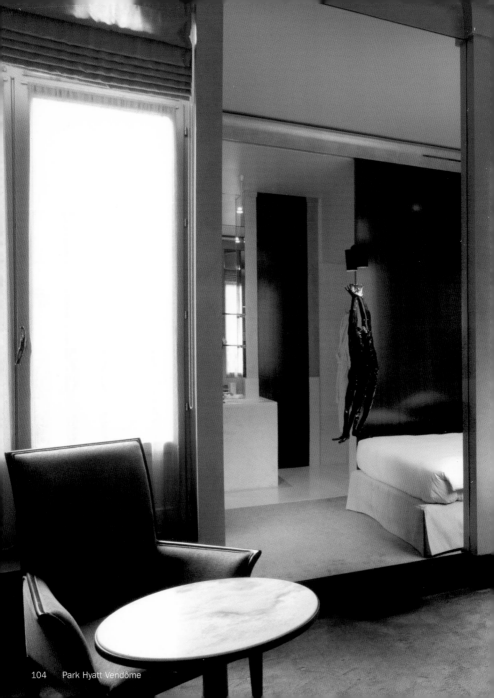

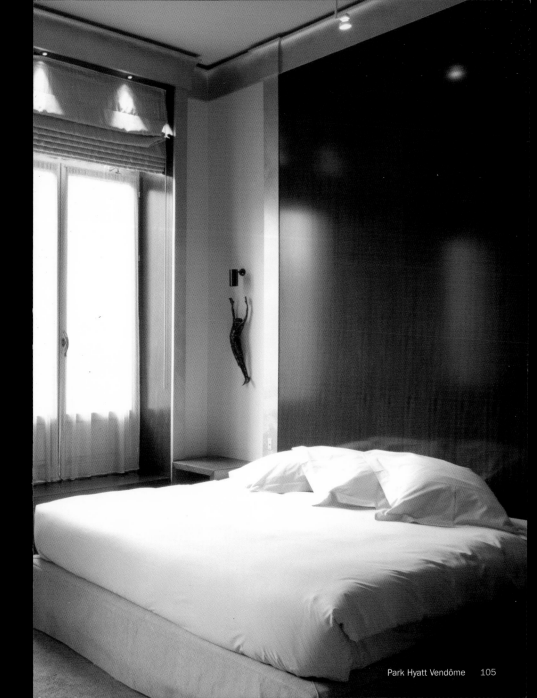

Pavillon de Paris

7, rue de Parme
75009 Paris
9e Arrondissement
Phone: +33 1 55 31 60 00
Fax: +33 1 55 31 60 01
www.pavillonparis.com

Price category: €€
Rooms: 30
Facilities: Lounge Bar
Services: Pets allowed, babysitters available, free Wi-Fi and Web TV
Located: Between Opéra Garnier and Montmartre
Métro: 2, 13 Place de Clichy
Map: No. 20
Style: Contemporary design
What's special: Furnished in accordance with the Feng Shui philosophy creating a home away from home and designed in a cool but elegant fusion of geometric patterns, creams and dark wood. The bar has an eastern feel to it with elements of black against mirrored pictures with Buddha statues.

Cool Shops nearby:
Van der Bauwede
Colette
Face à Face

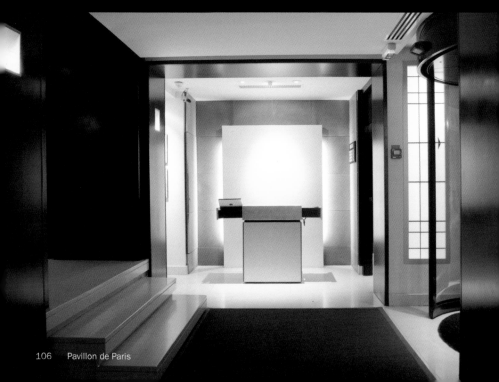

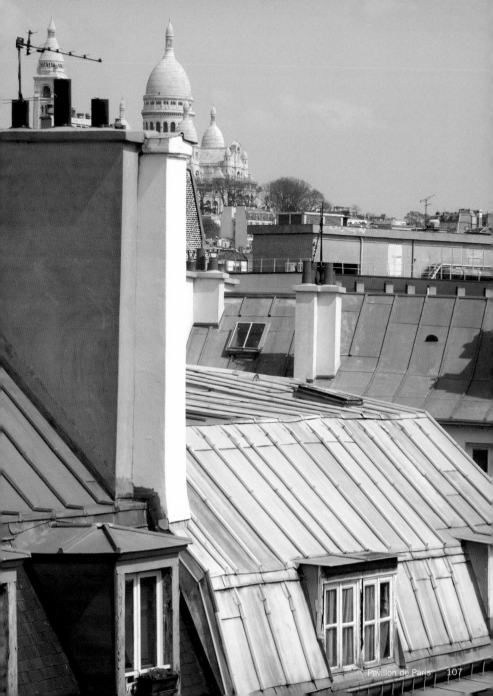

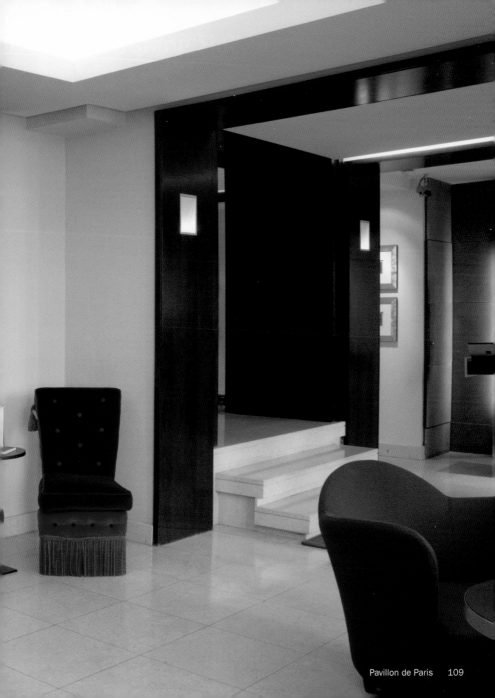

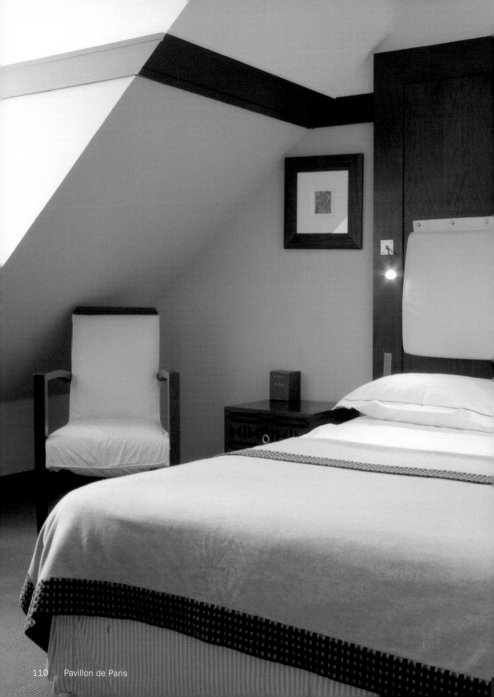

Pershing Hall

49, rue Pierre-Charron
75008 Paris
8e Arrondissement
Phone: +33 1 58 36 58 00
Fax: +33 1 58 36 58 01
www.pershinghall.com

Cool Restaurants nearby:
Mandala Ray
La Suite
Lô Sushi

Cool Shops nearby:
Dolce & Gabbana
Jean-Paul Gaultier
Peugeot Avenue

Price category: €€€
Rooms: 26 rooms and suites
Facilities: Restaurant, lounge bar, conference facilities
for up to 80 people, fitness, spa
Located: A step away from Champs-Elysées
Métro: 1 Franklin D. Roosevelt
Map: No. 21
Style: Contemporary design
What's special: The living areas are set around a vertical
garden draped in lush tropical plants from Southeast
Asia. Find a subtle color scheme of warm beiges and
grays, bead curtains, bathtubs with claw-and-ball feet
and comfortable, subtly contemporary furniture.

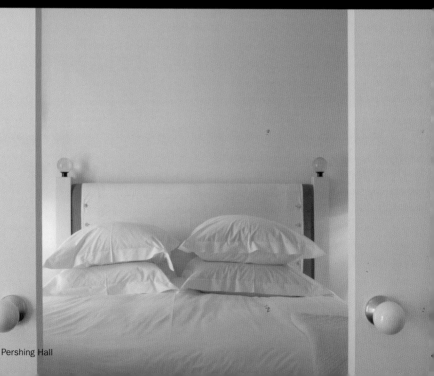

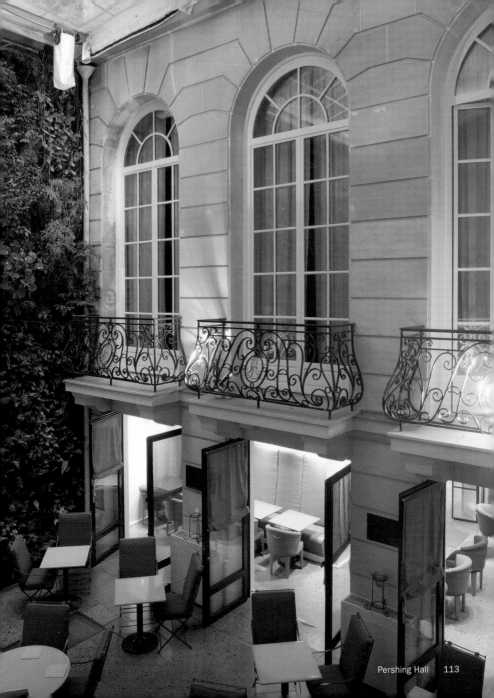

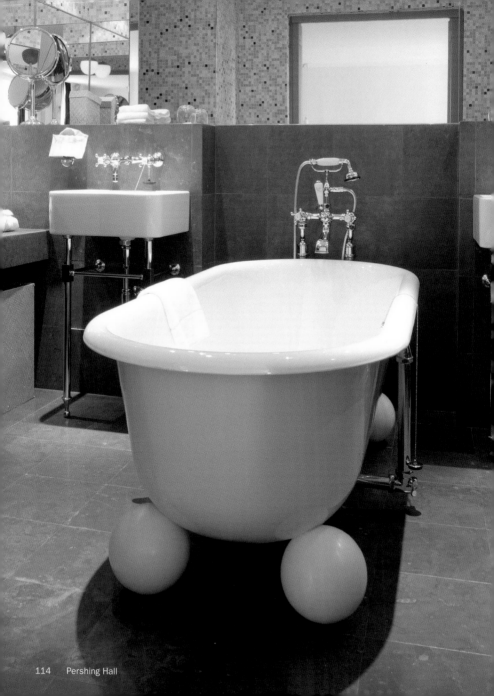

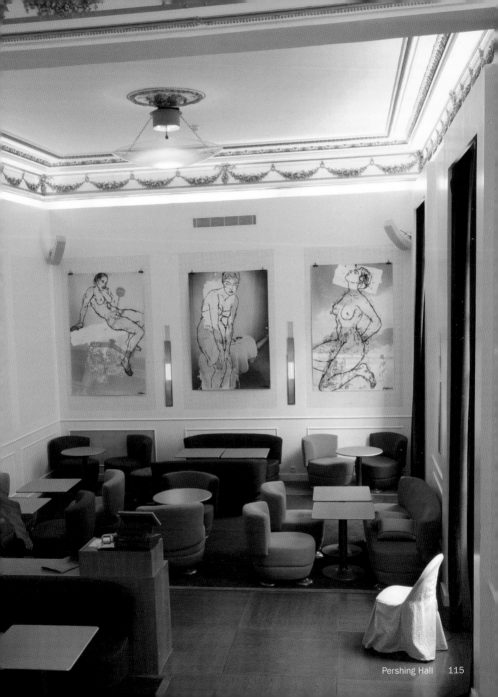

Phone: +33 1 42 74 10 10
Fax: +33 1 42 74 10 97
www.hoteldupetitmoulin.com

Cool Restaurants nearby:
Georges
Etienne-Marcel

Cool Shops nearby:
A-Poc Space
L'Atelier du Savon
Galerie Dansk

Services: Internet access, massage, pets (dogs and cats) are welcome, room massages on request
Located: Near the Picasso Museum, the Carnavalet Museum and the Place des Vosges
Métro: 8 Saint-Sébastien Froissart and Filles du Calvaire
Map: No. 22
Style: Contemporary design
What's special: An ancient bakery now houses a petite, eccentric hotel. The rooms, dreamed up by Christian Lacroix are an extravagant patchwork of textures, colors and influences. Walls are adorned with vast carnations, carpets are polka-dotted, and curtains get a style infusion with Marimekko patterns.

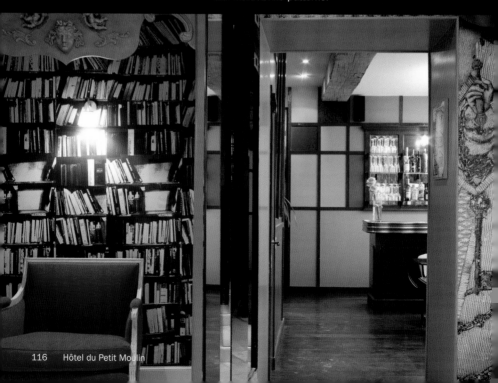

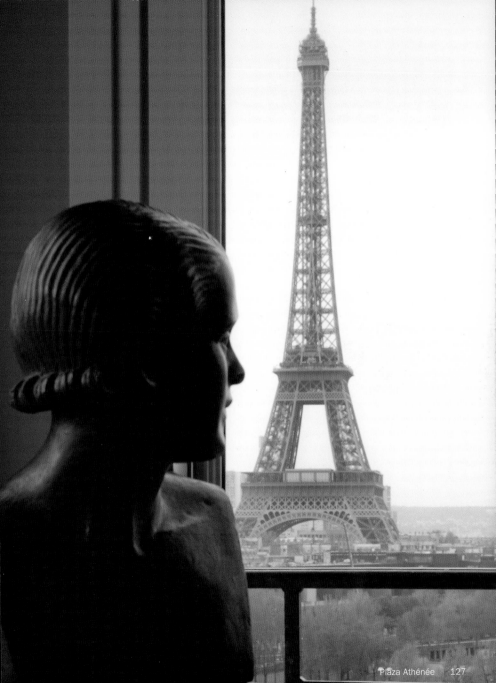

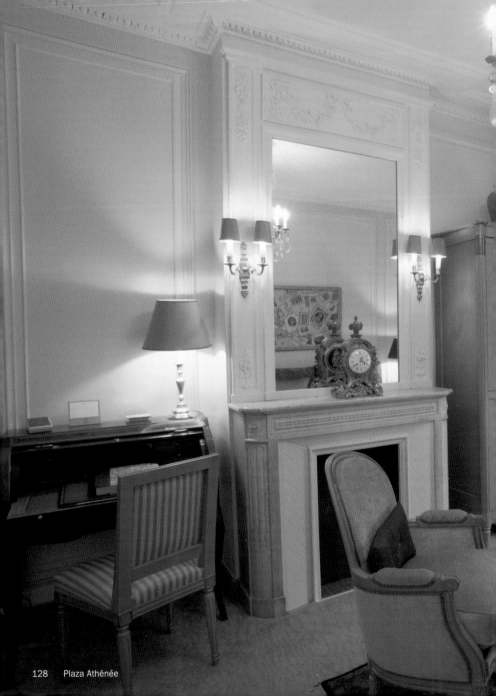

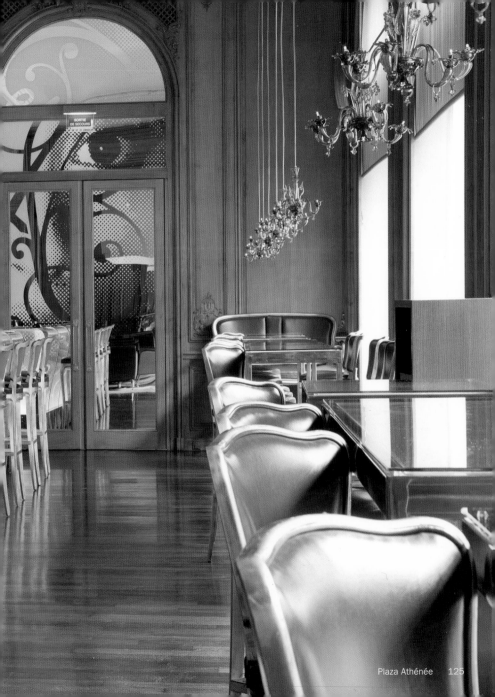

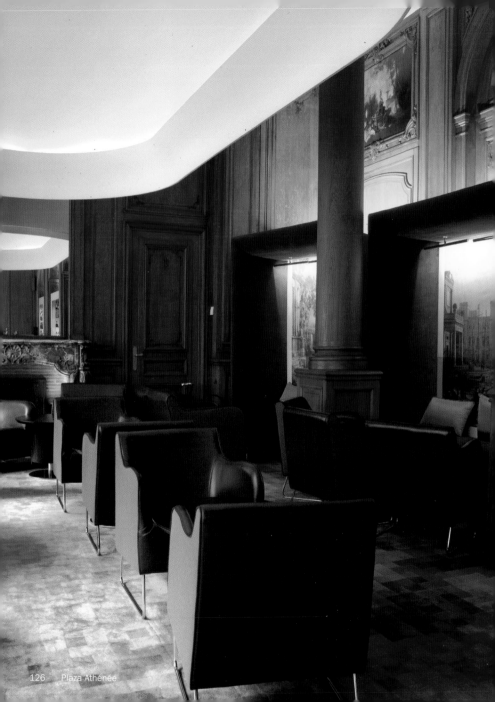

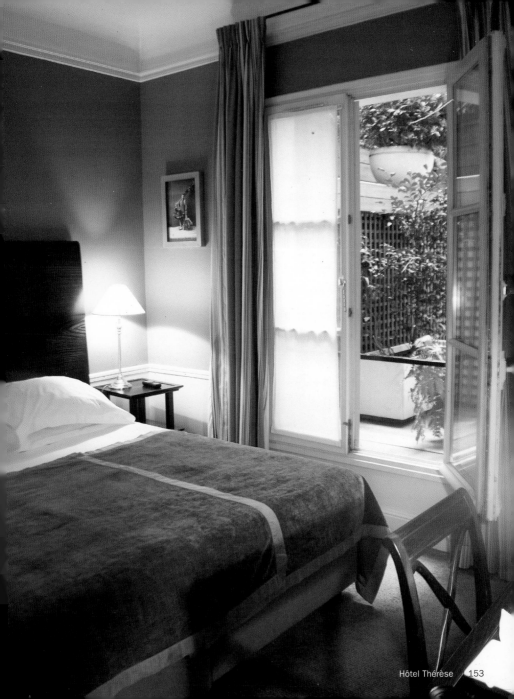

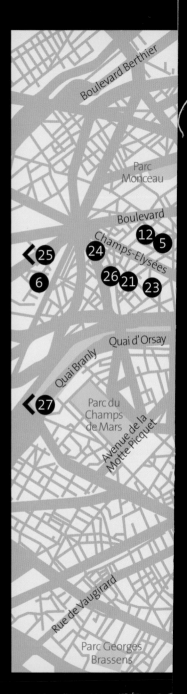

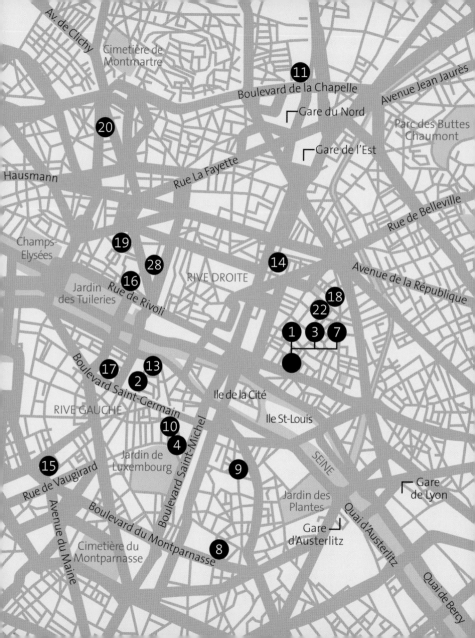

6 New York | 6, avenue de New-York | 16e arrondissement | Phone: +33 1 40 70 03 30 |

Alain Ducasse au Plaza Athénée | 25, avenue Montaigne | 8e arrondissement
Phone: +33 1 53 67 65 00 | www.plaza-athenee-paris.com

Arpège | 84, rue de Varenne | 7e arrondissement | Phone: +33 1 47 05 09 06 | www.alain-passard.com

Bertie | 6, rue Edouard VII | 9e arrondissement | Phone: +33 1 53 05 50 55 |

Brasserie Lipp | 151, boulevard Saint-Germain | 6e arrondissement | Phone: +33 1 45 48 53 91
www.brasserie-lipp.fr

Café de Flore | 172, boulevard Saint-Germain | 6e arrondissement | Phone: +33 1 45 48 55 26
www.cafe-de-flore.com

Café de l'Homme | 17, place du Trocadero | 16e arrondissement | Phone: +33 1 44 05 30 15
www.lecafedelhomme.com

Café Marly | Cour Napoléon 93, rue de Rivoli | 1er arrondissement | Phone: +33 1 49 26 06 60

Chez Paul | 13, rue de Charonne | 11e arrondissement | Phone: +33 1 47 00 34 57

Etienne-Marcel | 34, rue Etienne-Marcel | 2e arrondissement | Phone: +33 1 45 08 01 03

Fontaine Gaillon | place Gaillon | 2e arrondissement | Phone: +33 1 47 42 63 22

Georges | Centre Pompidou, 6th floor, 19, rue Beaubourg | 4e arrondissement
Phone: +33 1 44 78 47 99

Harry's Bar | 5, rue Daunou | 2e arrondissement | Phone: +33 1 42 61 71 14 | www.harrysbar.fr

Kong | 1, rue du Pont-Neuf | 1er arrondissement | Phone: +33 1 40 39 09 00 | www.kong.fr

La Suite | 40, avenue Georges V | 8e arrondissement | Phone: +33 1 53 57 49 49 | www.lasuite.fr

Lô Sushi | 8, rue de Berri | 8e arrondissement | Phone: +33 1 45 62 01 00 | www.losushi.com

Maison Blanche | 15, avenue Montaigne | 8e arrondissement | Phone: +33 1 47 23 55 99
www.maison-blanche.fr

Mandala Ray | 32–34, rue Marbeuf | 8e arrondissement | Phone: +33 1 56 88 36 36
www.manray.fr

Murano | 13, boulevard du Temple | 3e arrondissement | Phone: +33 1 42 71 20 00
www.muranoresort.com

The Cristal Room Baccarat | 11, place des Etats-Unis | 16e arrondissement
Phone: +33 1 40 22 11 10 | www.baccarat.fr

Tokyo Eat Palais de Tokyo | 13, avenue du Président-Wilson | 16e arrondissement
Phone: +33 1 47 200 00 29 | www.palaisdetokyo.com

Water Bar Colette | 213, rue Saint-Honoré | 1er arrondissement | Phone: +33 1 55 35 33 93
www.colette.fr

Cool Shops Paris

- Antoine et Lili | 95, quai de Valmy | 10e arrondissement | Phone: +33 1 42 05 62 23 | www.altribu.com
- A-Poc Space | 47, rue des Francs-Bourgeois | 4e arrondissement | Phone: +33 1 44 54 07 05
- Artelano | 54, rue de Bourgogne | 7e arrondissement | Phone: +33 1 44 18 00 00 | www.artelano.com
- Au nom de la rose | 46, rue du Bac | 7e arrondissement | Phone: +33 1 42 22 08 09 www.aunomdelarose.fr
- Biche de Bere | 61, rue de la Verrerie | 4e arrondissement | Phone: +33 1 42 78 22 03
- www.biche-de-bere.fr
- Boutique John Galliano | 384–386, rue Saint-Honoré | 1er arrondissement | Phone: +33 1 55 35 40 40 www.johngalliano.com
- Calligrane | 4–6, rue du Pont-Louis-Philippe | 4e arrondissement | Phone: +33 1 48 04 31 89
- Chantal Thomass | 211, rue Saint-Honoré | 1er arrondissement | Phone: +33 1 42 60 40 56
- Colette | 213, rue Saint-Honoré | 1er arrondissement | Phone: +33 1 55 35 33 90 | www.colette.fr
- Dolce & Gabbana | 22, avenue Montaigne | 8e arrondissement | Phone: +33 1 42 25 68 78 www.dolcegabbana.it
- Face à Face | 346, rue Saint-Honoré | 1er arrondissement | Phone: +33 1 53 45 82 22 www.faceaface-paris.com
- Fresh | 5, rue du Cherche-Midi | 6e arrondissement | Phone: +33 1 53 63 33 83 | www.fresh.com
- Galerie Dansk | 32, rue Charlot | 3e arrondissement | Phone: +33 1 42 71 45 95
- Galerie Kreo | 22, rue Duchefdelaville | 13e arrondissement | Phone: +33 1 53 60 18 42 www.galeriekreo.com
- Gucci | 60, avenue Montaigne | 8e arrondissement | Phone: +33 1 56 69 80 80 | www.gucci.com
- Jean-Paul Gaultier | 44, avenue George V | 8e arrondissement | Phone: +33 1 44 43 00 44 www.jeanpaul-gaultier.com
- Knoll International | 268, boulevard Saint-Germain | 7e arrondissement | Phone: +33 1 44 18 19 99 www.knoll.com
- L'Atelier du Savon | 29, rue Vielle-du-Temple | 4e arrondissement | Phone: +33 1 44 54 06 10 www.savonparis.com
- Les Salons du Palais Royal Shiseido | 142, Galerie de Valois – 25, rue de Valois, Jardins du Palais Royal | 1er arrondissement | Phone: +33 1 49 27 09 09 | www.salons-shiseido.com
- Louis Vuitton | 54, avenue Montaigne | 8e arrondissement | Phone: +33 1 45 62 47 00 www.vuitton.com
- Michel Perry | 243, rue Saint-Honoré | 1er arrondissement | Phone: +33 1 42 44 10 07 www.michelperry.com
- Orizzonti | 28, rue d'Assas | 8e arrondissement | Phone: +33 1 42 22 43 35 | www.arenafurniture.com
- Peugeot Avenue | 136, avenue de Champs-Elysées | 8e arrondissement | Phone: +33 1 42 89 30 20 www.peugeot.com
- Van der Bauwede | 16, rue de la Paix | 2e arrondissement | Phone: +33 1 42 60 48 48 www.vanderbauwede.ch
- Zero one one | 2, rue de Marengo | 1er arrondissement | Phone: +33 1 49 27 00 11 www.zeroone.com

COOL HOTELS CITY

Size: **15 x 19 cm**,
6 x 7 ¹/₂ in., 160 pp.,
Flexicover, c. 200
color photographs
Text: English /
German / French /
Spanish / Italian

Cool Hotels London
ISBN 978-3-8327-9206-0

Cool Hotels New York
ISBN 978-3-8327-9207-7

Cool Hotels Paris
ISBN 978-3-8327-9205-3

Related books by teNeues

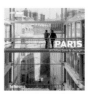

Paris City Highlights
ISBN 978-3-8327-9195-7

Paris and :guide
ISBN: 978-3-8238-4579-7

Cool Restaurants Paris
ISBN 978-3-8327-9129-2

Cool Shops Paris
ISBN 978-3-8327-9037-0

Size: **15 x 19 cm**,
6 x 7 ¹/₂ in.
160 pp., **Flexicover**
c. 300 color photographs
Text: English / French /
Spanish / Italian

Size: **13 x 13 cm**,
5 x 5 in. (CD-sized
format), 192 pp.,
Flexicover, c. 200 color
photographs and plans.
Text: English / German /
French / Spanish

Size: **14.6 x 22.5 cm**, 5³/₄ x 8³/₄ in., 136 pp.,
Flexicover, c. 130 color photographs,
Text: English / German / French / Spanish / Italian

Published in the COOL HOTELS Series

ISBN: 978-3-8327-9105-6

ISBN: 978-3-8327-9051-6

ISBN: 978-3-8238-4565-2

ISBN: 978-3-8238-4581-2

ISBN: 978-3-8327-9134-6

ISBN: 978-3-8327-9135-3

ISBN: 978-3-8238-4582-9

ISBN: 978-3-8327-9203-9

ISBN: 978-3-8327-9136-0

Size: **13.5 x 19 cm**, 5 $^1/_4$ x 7 $^1/_2$ in., 400 pp., **Flexicover**, c. 400 color photographs,
Text: English / German / French / Spanish / Italian